PLYMOUTH REFLECTIONS

Derek Tait & Wesley Ashton

AMBERLEY

Bibliography

Books

Images of England: Plymouth, Derek Tait (Tempus, 2003)
Memories of St Budeaux, Derek Tait (Driftwood, Coast 2009)
Plymouth at War, Derek Tait (Tempus, 2006)
Plymouth Hoe, Derek Tait (Driftwood Coast, 2008)
Saltash Passage, Derek Tait (Driftwood Coast, 2007)
St Budeaux, Derek Tait (Driftwood Coast, 2007)
Then & Now, Chris Robinson (Pen & Ink, 2020)

Websites

Chris Robinson at www.chrisrobinson.co.uk
Derek Tait at derektait.weebly.com
Hidden Heritage at www.facebook.com/hiddenheritageofficial

Newspapers

The Evening Herald
The Western Independent
The Western Morning News
The Western Weekly Mercury

First published 2023

Amberley Publishing
The Hill, Stroud, Gloucestershire, GL5 4EP
www.amberley-books.com

Copyright © Derek Tait & Wesley Ashton, 2023

The right of Derek Tait & Wesley Ashton to be identified
as the Authors of this work has been asserted in
accordance with the Copyrights, Designs and Patents
Act 1988.

ISBN 978 1 3981 0726 7 (print)
ISBN 978 1 3981 0727 4 (ebook)

British Library Cataloguing in Publication Data.
A catalogue record for this book is available from the
British Library.

Typesetting by SJmagic DESIGN SERVICES, India.
Printed in Great Britain.

Introduction

Plymouth is an ever-changing city and new buildings alter the skyline constantly. The look of the city has changed greatly, even over the last few years with drastic developments to the city centre including the building of the Beckley Point twenty-three-storey skyscraper; the building of The Box, Plymouth's £40 million history and art centre; the start of construction of Millbay Boulevard; new developments at Quadrant Wharf, Peirson House and Mayflower Court, as well as an £80 million plan to revamp the city's main railway station. One of the latest changes appears at West Hoe where Sir Anthony Gormley's statue *Look II* now stands at West Pier.

During the war, Plymouth was devastated by enemy bombing and much of the old city was lost forever. A new plan was put forward to construct a modern city with wide, modern streets and the heart of this still stands in the city centre today. Many photos within this book show the utter devastation which affected the city during the Blitz.

In this book we have tried to show some of the great changes that have taken place in Plymouth over the years. The cityscape has vastly changed with the demolishing and rebuilding after the war and some scenes are almost unrecognisable today. As well as buildings, many modes of transport have also disappeared including trams and horses and carts. Even cars have changed dramatically over the years.

Amazingly, some areas have changed very little and the only difference appears to be modern lamp posts, telephone masts, modern vehicles and wheelie bins. Some scenes have changed so much that it's almost impossible to work out the location of the original photo. The clues are there though, and with a bit of detective work, including visits to the library and trawling through old newspapers, it soon becomes apparent where the original photo was taken.

A few photos within the book feature old trams and many people might not realise what an extensive system of trams once ran through the city running from Derry's Clock in the city centre, covering many parts of Devonport and Stonehouse and running as far as Saltash Passage, where passengers could get off to enjoy the annual regatta, the Little Ash Tea Gardens, the St Budeaux Carnival or continue their journey by ferry over the Tamar to Saltash.

Many train stations such as the ones at Millbay and Devonport have also long since disappeared. Millbay was once a very busy and popular station and many celebrities including Charlie Chaplin, Noel Coward, Harry Houdini and Laurel and Hardy would have passed through here. Chaplin and Coward were guests of the Astors, who lived at Elliot Terrace on the Hoe, and Houdini and Laurel and Hardy appeared at the once popular Palace Theatre of Varieties in Union Street.

The book includes many photos of the heart of the city but also features photos of the Barbican, the Hoe and outlying districts. As well as transport, fashion has changed greatly and the whole city has become a vastly busier and more populated place.

All the modern photos featured in this book have been taken by Wesley Ashton who has spent a lot of time finding the exact locations of the older photos so that readers can see how much an area has changed since the original photo was taken. He's certainly done

a great job and this book wouldn't be what it is without him. Wesley, together with Paul Diamond, run the local history group Hidden Heritage whose Facebook page can be found at https://www.facebook.com/hiddenheritageofficial

I hope that you will find this collection of merged old and new photos, together with their captions, both informative and enjoyable.

Acknowledgements

Photo credits: The Derek Tait Picture Library, Wesley Ashton, Maurice Dart, Steve Johnson, Chris Robinson, Marshall Ware and Jerry Richards.

Thanks to all the people who have written to me over the years sending their memories and photos. Thanks also to Tina Cole, Ellen Tait, Alan Tait, Tilly Barker and Sadie Bond. I have tried to track down the copyright owners of all the photos used and apologise to anyone who hasn't been mentioned. I will make any amendments at the first opportunity.

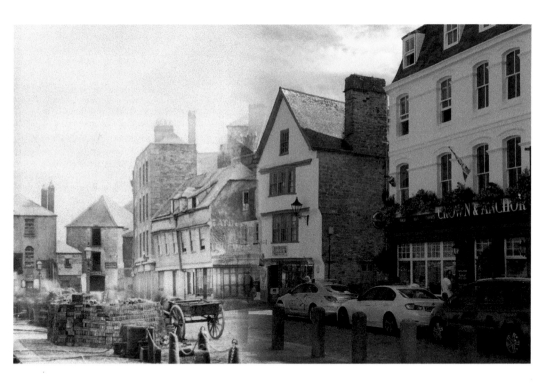

The Barbican

It's amazing how empty the scene is in the older photo taken well over 100 years ago. At the time, there would have been much activity with fishermen offloading their catch. Some of the buildings have now been demolished but many remain. In the centre of both photos can be seen the Island House with the South Western Railway Offices building on the left.

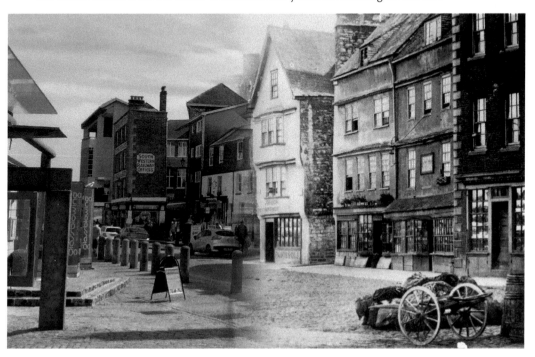

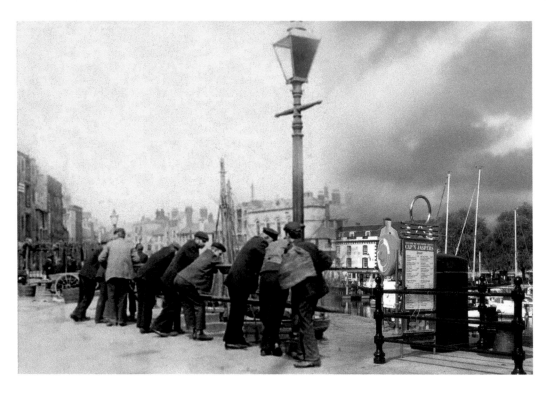

Men Gathered around the Harbour on the Barbican

Much has changed between the taking of these two photos. The Customs House and the Three Crowns building can be seen in both pictures but buildings on the right of the photo have long since disappeared. The warehouse buildings on the left of the older photo now house cafes and restaurants.

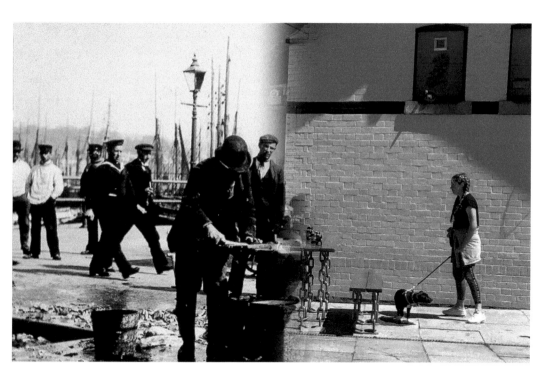

Tom Fry and His Wife Gutting Fish on the Barbican

At one time, the cobbles would be covered in fish guts as the morning's catch was busily cleaned and prepared for the daily fish auctions. An old law stated that 'ffyshe, flesh, deaded beasts or dogges, cattes and swyne' were not to be thrown off the Quay. It's a very different scene today. Tourists flock to the area and the very busy cafe, 'Cap'n Jaspers', which stands in the location of the older photograph.

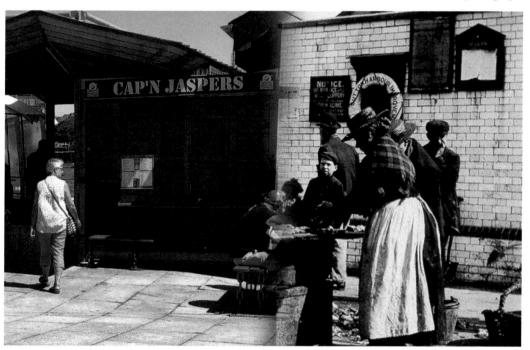

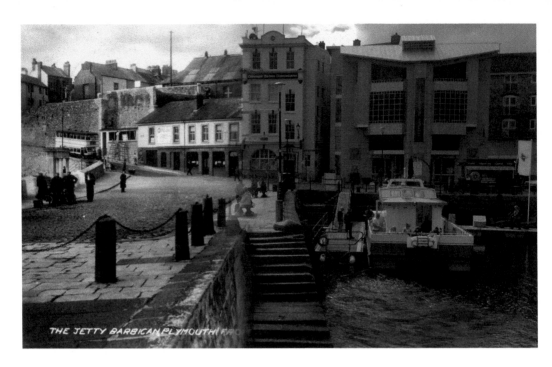

The Jetty, the Barbican

Many of the buildings in the first photo are still there today. The main difference in these two photos is that a much more modern building, the Mayflower Visitor Centre, now stands where Simonds once was. Much remains the same apart from more modern cars, vans and boats. The Admiral McBride Public House stands on the left of both photos and within the ladies toilet is a marker showing the point where the Pilgrim Fathers left from in 1620. The waters of the Quay once came much further back before the jetty was built.

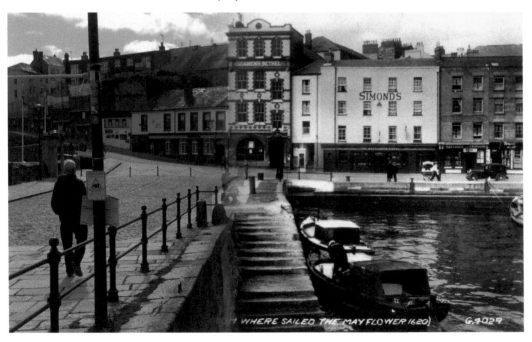

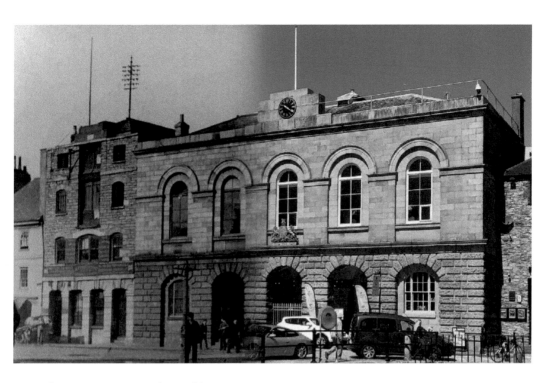

The Customs House, the Barbican

The Customs House was built in 1820 and looks much the same today as it did back then. The original customs house stood across the way and is now a bookshop. Smuggling was once rife and the trade of contraband was very lucrative. To the right of the modern photo is the popular public house The Three Crowns.

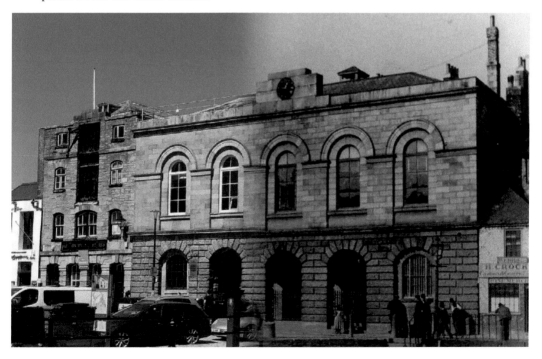

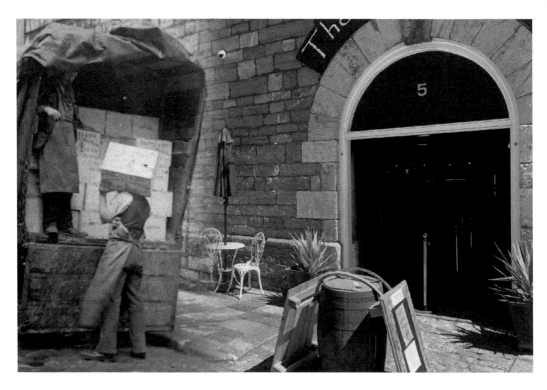

Black Friars Distillery, the Barbican

The building seen here once belonged to Coates and Co., who have produced Plymouth Gin since 1793. The top photo was taken in 1906 and shows a wagon being loaded up with cases of liquor. Today, the same building houses The Bottling Plant – a cafe and wine bar.

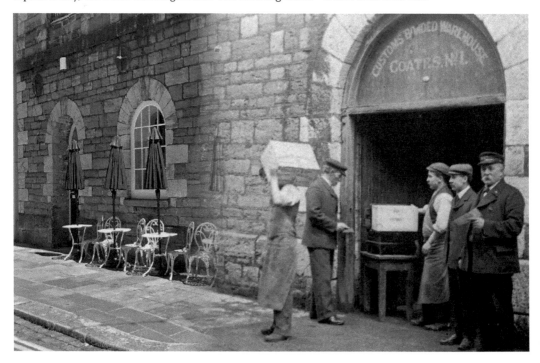

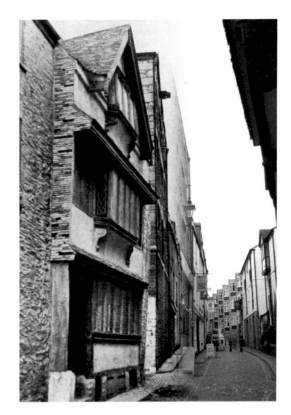

The Elizabethan House, New Street, the Barbican

In 1584, the Mayor of Plymouth, John Sperkes, approved the building of New Street to house people who made their livelihood in and around the harbour. William Hele was the first recorded occupant in 1631. The house is open to the public and also includes an interesting Elizabethan garden. Many buildings in New Street still stand although, in the modern photograph, more recent dwellings can be found on the right.

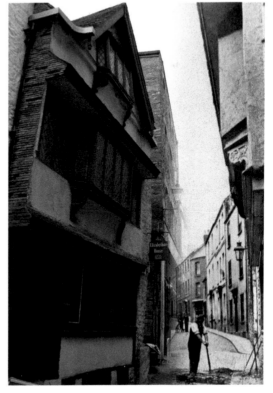

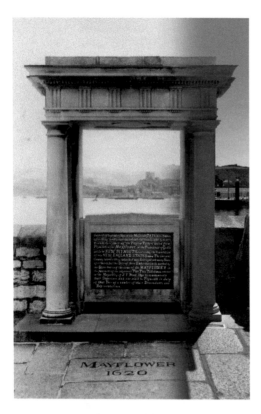

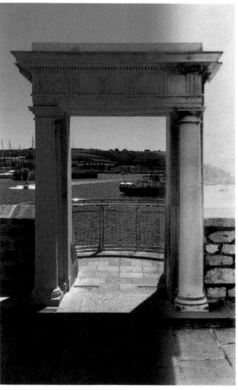

The Mayflower Memorial, the Barbican
These two photos show the Mayflower Memorial with Mount Batten in the background. In the later photo, the water taxi to Mount Batten can be seen. Many visitors to the Barbican think that this was the leaving place of the Pilgrim Fathers in 1620 but, as mentioned earlier, this is reclaimed land and the actual leaving place is further back within the nearby Admiral McBride Public House.

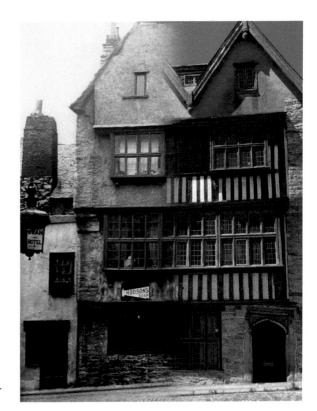

The Merchant's House

Originally built as a wealthy merchant's house in the 1600s, it replaced an earlier house which stood on the same spot in the 1500s. At least three mayors lived at the house including its first owner, William Parker. In 1972, Plymouth City Council bought the house, restoring it to its original glory. Oddly, the modern photo is more accurate to its original appearance in the 1600s than the older photo is.

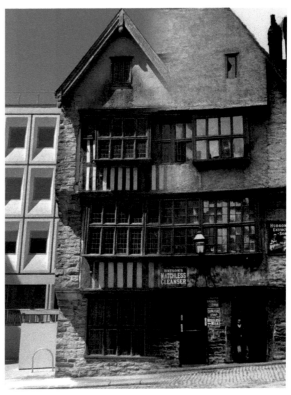

13

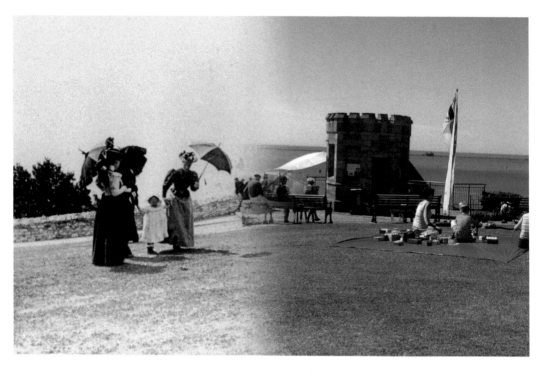

Parasols on the Hoe

The earlier photo shows ladies promenading on Plymouth Hoe complete with their parasols. Apart from the fashions, little has changed over the years in this area of the Hoe. The liner lookout was once used to spot incoming steamers. Today, it's the Liner Lookout Cafe.

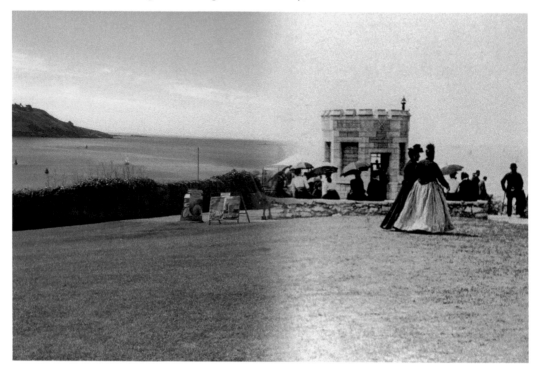

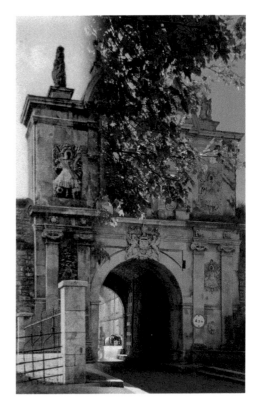

The Citadel Gates

Only the uniforms and weapons seem to have changed between the taking of these two photos. Work commenced on the Citadel in 1665 under the orders of Charles II who feared an invasion by the Dutch. Cannons on the Citadel face towards the town, as well as out to sea, as a warning to locals who supported Cromwell during the Civil War.

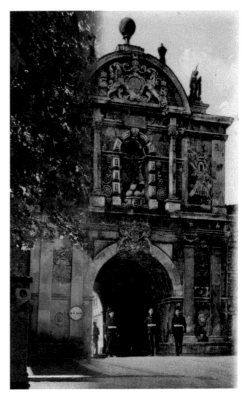

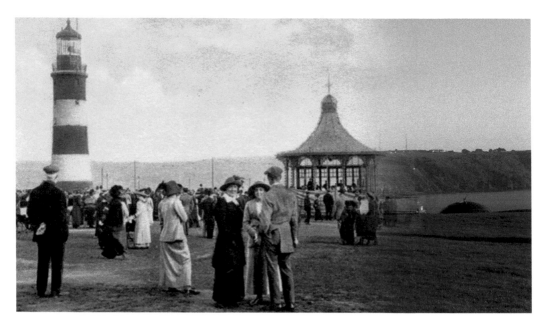

Smeaton's Tower and the Bandstand

A busy scene from around 1910 shows crowds of spectators gathering to watch the band play. The modern photo shows a more empty Plymouth Hoe with the bandstand long gone. Smeaton's Tower today is painted in its original red and white colour but has had various colour schemes over the years including green and white, the colours of Devon.

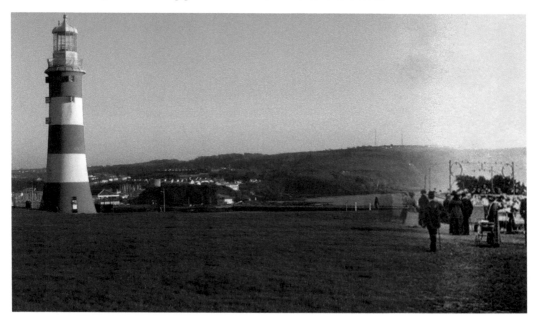

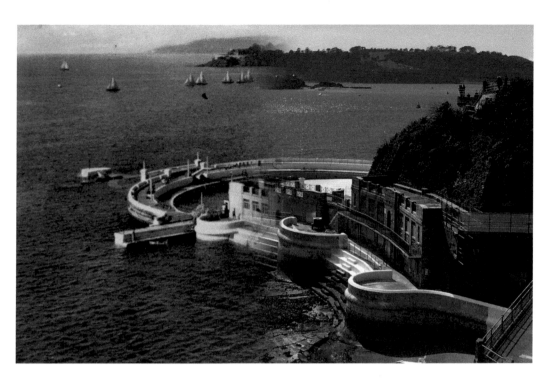

The Lido, Plymouth Hoe

The Lido was opened in 1935 and the older photo shows an empty scene in the 1950s. During the years, the pool has been a very busy and popular area but interest in it waned in the 1980s. Today, it has been refurbished and has attracted new visitors but doesn't seem to be as popular as it once was.

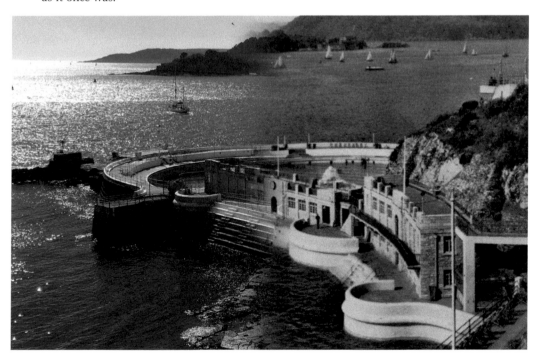

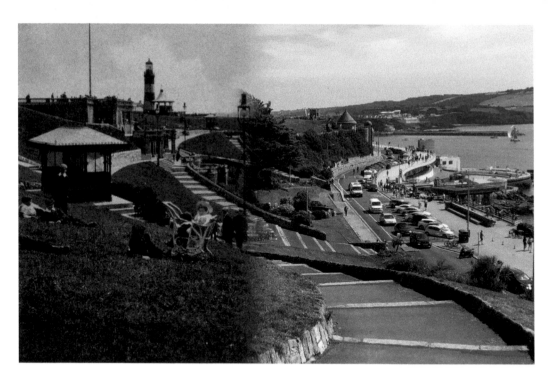

The Hoe Slopes

The older photo taken in around 1910 shows two landmarks that have long gone, the Pier and the Bandstand. Both were victims of the Second World War. However, much has remained the same in these two photos with only the fashions and modes of transport having changed. There is one addition in the new photo and that's the Plymouth Dome building which opened in 1989 but has had several uses over the years including a small museum and later a restaurant.

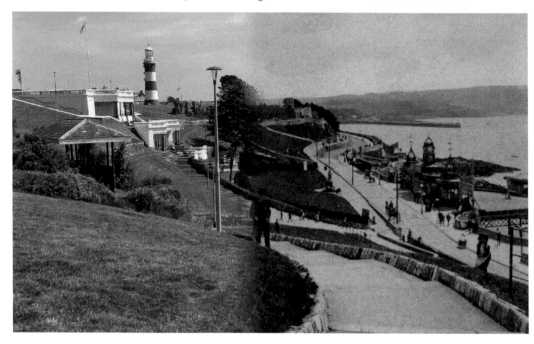

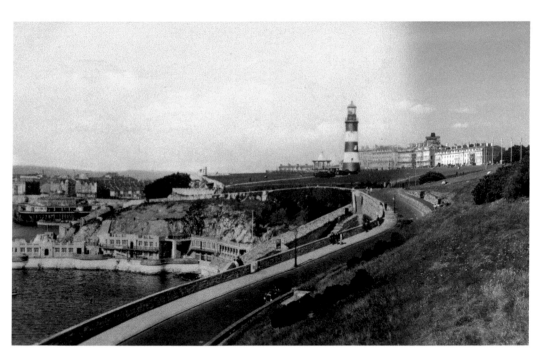

Madeira Road, Plymouth Hoe

These two photos show how little has changed over the years. The first was taken in the 1930s and a solitary car can be seen on the road. At the time, the Pier was still in place in the background and the Lido was yet to be built. The later photo shows more cars and the newer Azure building, built in 2007, can be seen in the far background.

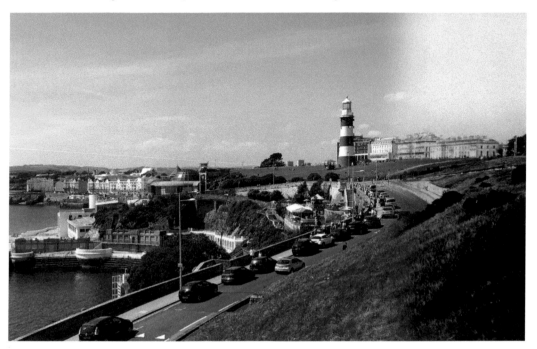

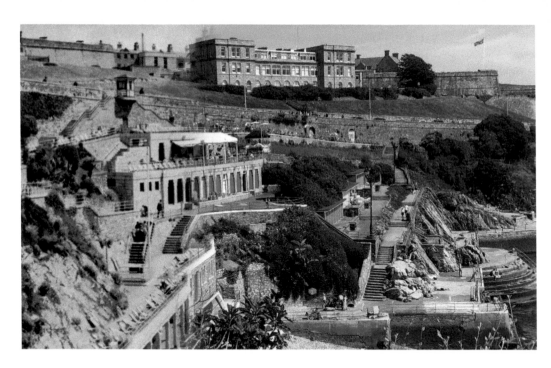

The Terraces, Plymouth Hoe

There are subtle changes between these two photos which at first may be hard to spot. The first photo was taken in the early 1960s and on the hill can be seen the headquarters of the Marine Biological Association which was opened in 1888. The terraces and beach hut changing rooms remain much the same with the only real noticeable difference being the canopies over the small cafe near the centre of the picture.

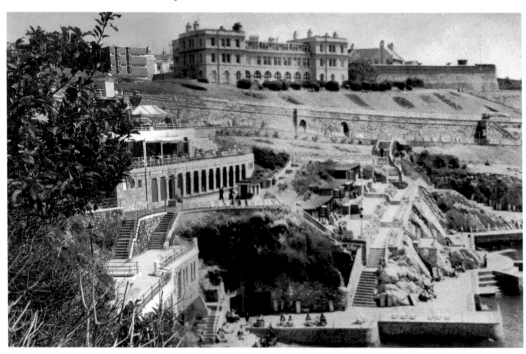

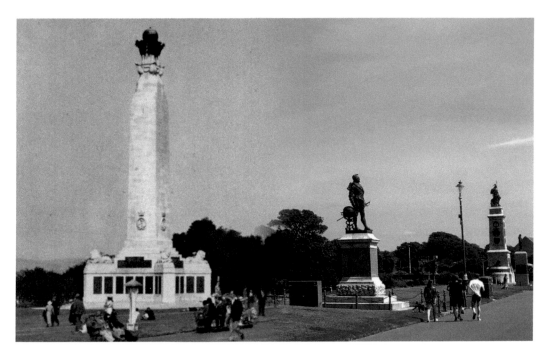

The War Memorial, Plymouth Hoe

The pre-war scene shows many people strolling along the Promenade enjoying the views and good weather. After the Second World War, the War Memorial was extended. The modern photo shows a quieter scene with the statue of Sir Francis Drake very much in the forefront.

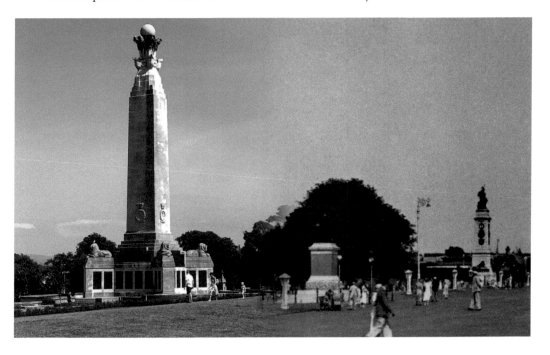

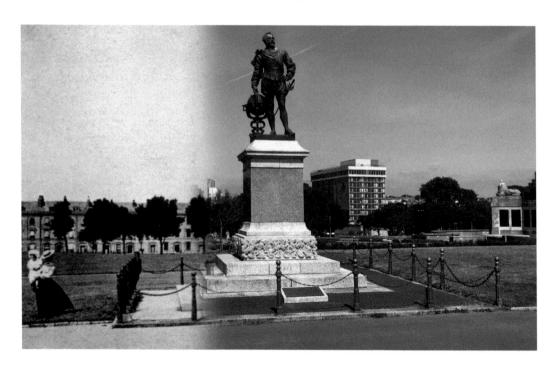

Drake's Statue, Plymouth Hoe

The early photo shows a lady in a boater hat with a small child beside the statue of Sir Francis Drake. The statue, which looks out towards Plymouth Sound, was unveiled by Lady Fuller Drake on 14 February 1884. The statue was a copy of the one erected at Tavistock by the Duke of Bedford. Drake had no direct descendants and Lady Fuller was the wife of Sir Francis Fuller Drake who was a descendant of Drake's brother, Thomas.

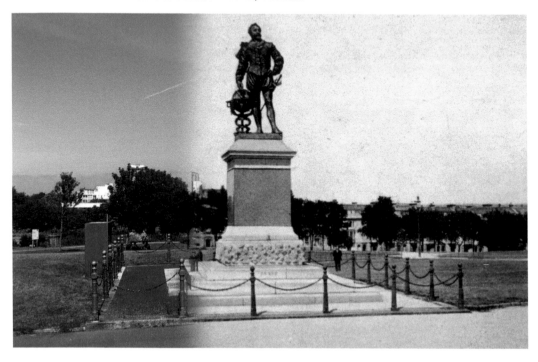

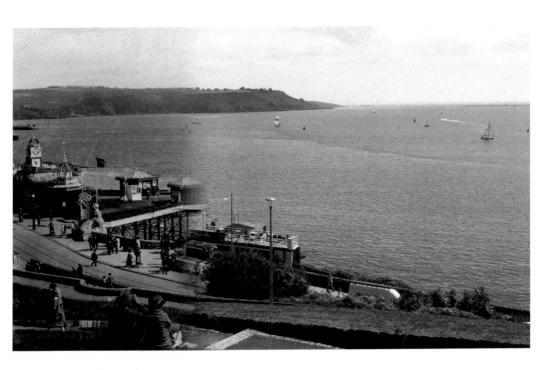

The Pier, Plymouth Hoe

The old photo from the early 1900s shows Plymouth Pier in all its glory. It was built in 1884 and proved to be very popular. The Pier contained a stationery and book stall, a reading room, slot machines and a post office. The Pavilion hosted concerts in its large theatre and it was used for roller skating, wrestling, boxing, military shows and dancing. It was a casualty of the bombing of the Second World War and was never rebuilt. Today, looking at the scene, it's hard to imagine that it was ever there.

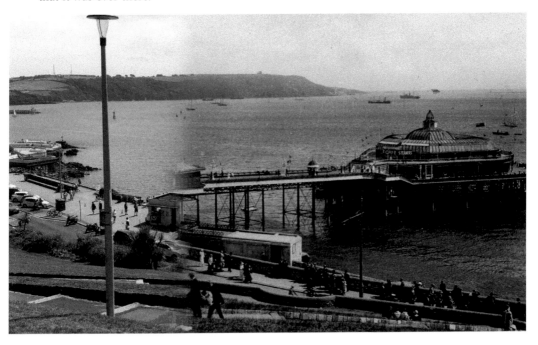

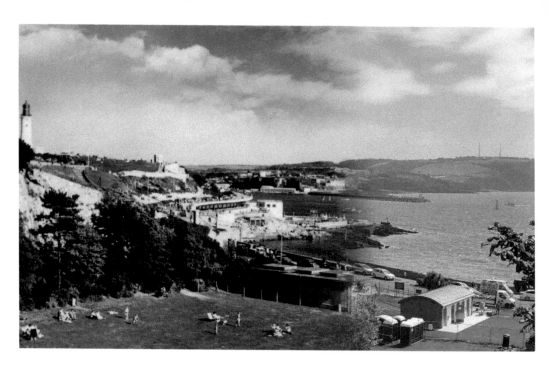

West Hoe

The first photo was taken in the early 1960s and shows Smeaton's Tower when it was painted white. The following almost sixty years hasn't brought much change to the area. The trees have grown, partly obscuring the view, and Smeaton's Tower has now been repainted in its original colours. Families still enjoy relaxing on the large grassed area shown, especially in the summer months.

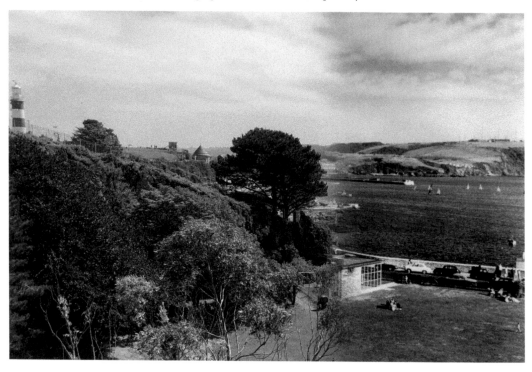

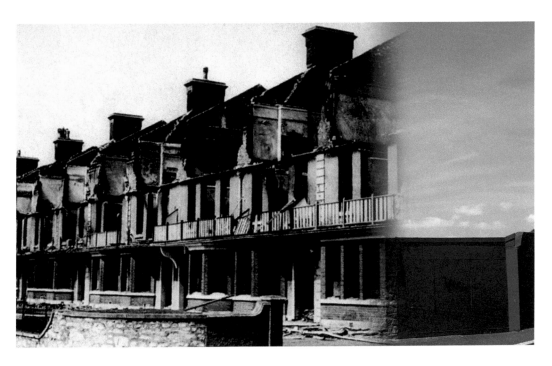

Cliff Road, the Hoe

The houses in the older photo once stood on Cliff Road and were known simply as The Terrace. They had uninterrupted views across Plymouth Sound and were much sought after. From the first photo, you can see that they were badly damaged by enemy bombing during the Second Word War. A few years after the war, they were demolished and until recently The Quality Hotel stood in their place, but this has now also been demolished.

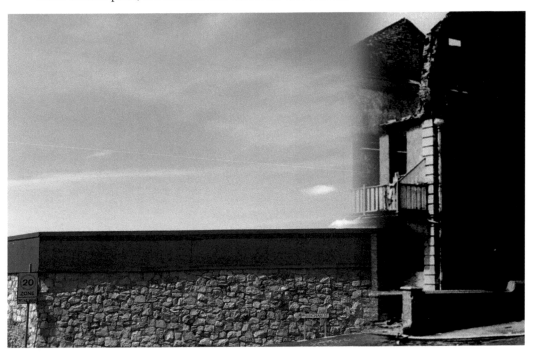

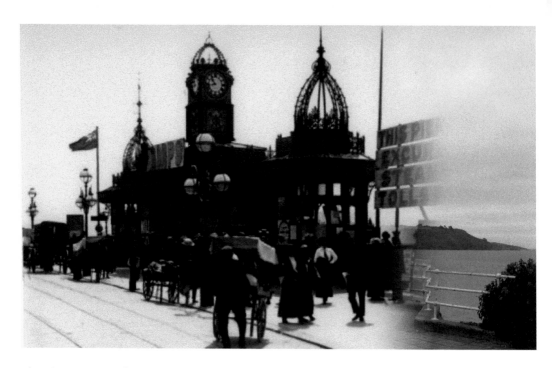

The Pier Entrance, the Hoe

The older photo, taken in the early 1900s, shows much activity around the grand pier entrance. There are many people with handcarts selling their wares; one is selling 'pure ice cream' while another man sells newspapers. There are many adverts including ones for the *Daily Mercury* and others advertising many steamboat excursions that could be taken from the Pier. Today, it's all gone and a concrete seating area looks out towards the Sound.

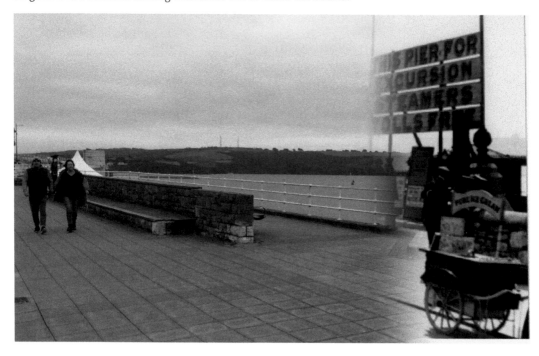

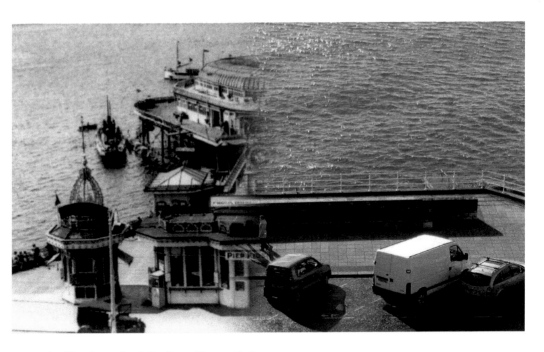

The Pier from the Belvedere, Plymouth Hoe

The grandeur of Plymouth's pier can be seen in the older photo. The time on the clock reads twenty to eleven in the morning and a sign in the background advertises concerts, steamers and a cafe. To the right of the ornate entrance are several slot machines. The scene in the later photo looks very dull in comparison.

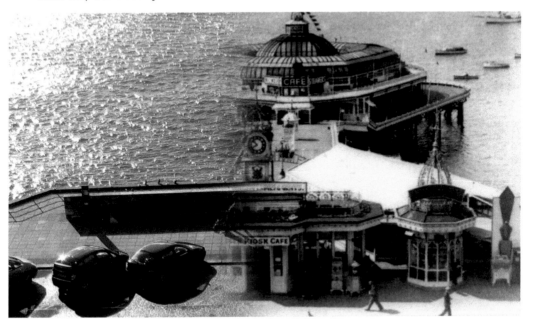

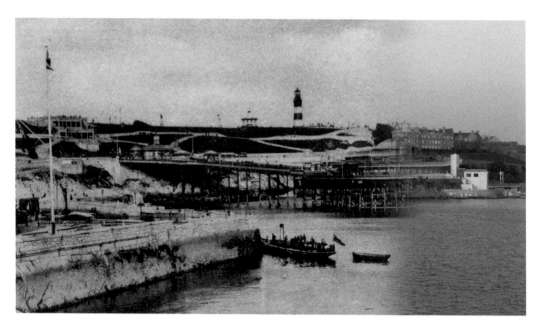

The Hoe from Plymouth Sound

One hundred years separate these two photos and the main differences are the War Memorial, the Plymouth Dome and the disappearance of the Bandstand. The Mallard Cafe stood in prime position for many years and had views right across Plymouth Sound. Its replacement, the Dome, now houses Ocean View Bar and Dining at the Dome, both of which opened in 2021.

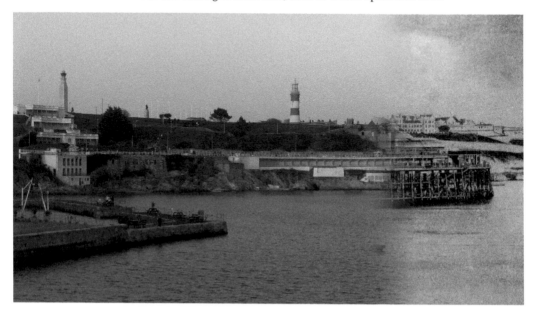

The Boat Pier, West Hoe

The building on the right of the earlier photo, taken in the 1950s, is the now demolished grain silo at Millbay. Behind the small quay, new apartment buildings were built in keeping with the original buildings that already stood there. These were completed in the 1980s. A newer apartment block stands to the right of these on the site of the old tennis court.

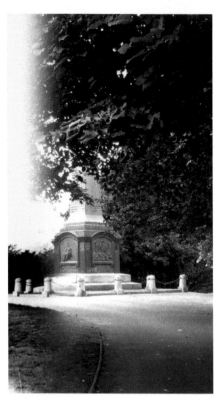

The Boer War Memorial

The Boer War Memorial was unveiled on 8 August 1903 by Lady Audrey Buller. Little has changed in these two photos apart from the stone edging on the grass and the disappearance of the communal bench. The ornate bronze plaques on each side of the memorial, probably once highly polished, have today been covered with a similar-coloured brown paint.

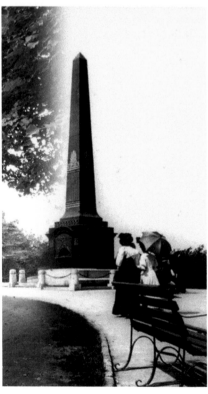

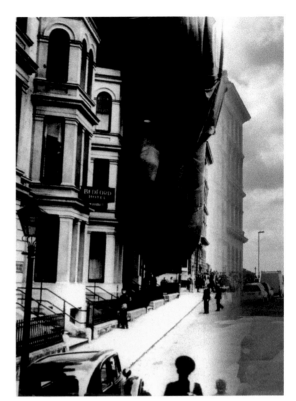

The Strathmore Hotel, Plymouth Hoe
The wartime photo shows a barrage balloon which had crashed onto the Strathmore Hotel in Elliot Street. Little has changed between these two photos and the hotel is still open for business today. The road leads up to the Hoe and also towards Elliot Terrace, which was once the home of Lord and Lady Astor.

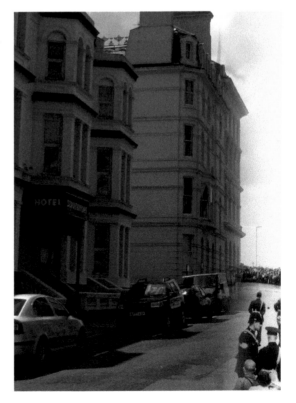

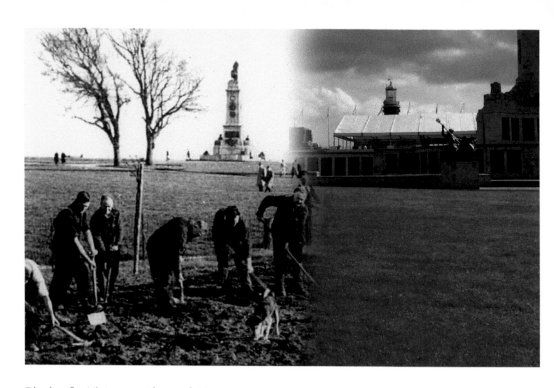

Digging for Victory on Plymouth Hoe

With food shortages during the Second World War, many of Plymouth's city parks were turned into allotments. Here, local men can be seen planting potatoes on land close to the Armada Memorial. Vegetables were not rationed but were often in short supply. People who had gardens were encouraged to plant vegetables instead of flowers.

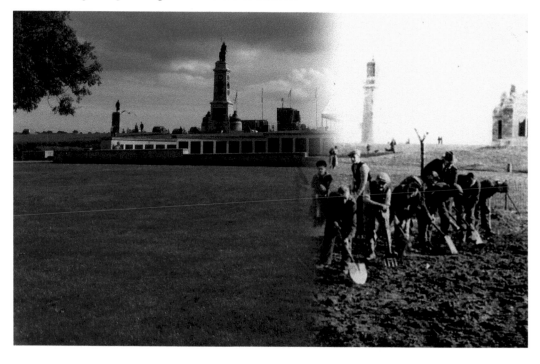

Millbay Station

Millbay Station was another casualty of the Second World War. It was first opened in 1849 and proved to be very busy. It was bombed in 1941 and was closed to passengers shortly afterwards. Nowadays, the land is occupied by the Pavilions, an entertainment centre. The lower photo shows the Mount Pleasant Hotel which has now been removed.

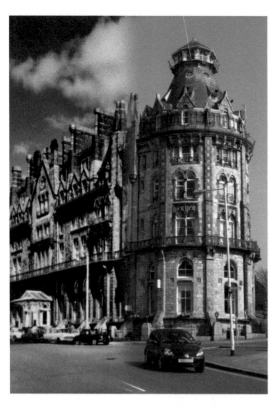

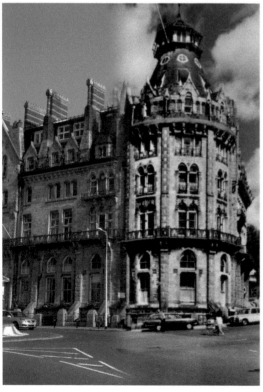

The Duke of Cornwall Hotel
The hotel was opened opposite Millbay Station in 1862 to cater for many rail passengers who would later be travelling onwards by train or travelling on one of the many passenger liners that called regularly into the city. It narrowly escaped bombing in the Second World War and remains much the same today.

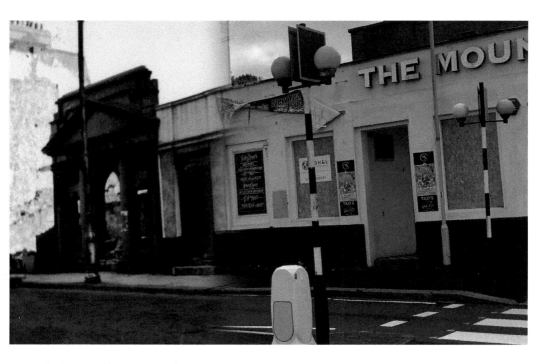

The Mount Pleasant Hotel

The Mount Pleasant Hotel stood next to the Duke of Cornwall Hotel but, as can be seen from the earlier photo, didn't fare so well during the bombing in the Second World War. Amazingly, it wasn't demolished but was rebuilt in much the same style as it was originally. The building has now been demolished and serves as a small car park for the nearby Duke of Cornwall Hotel.

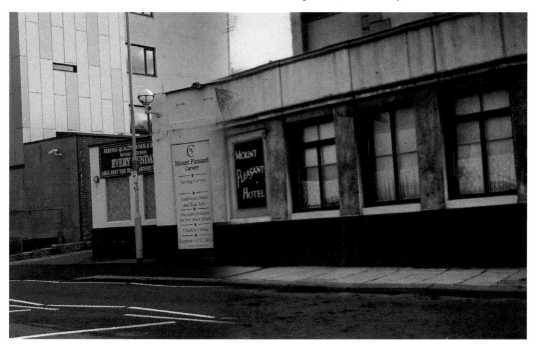

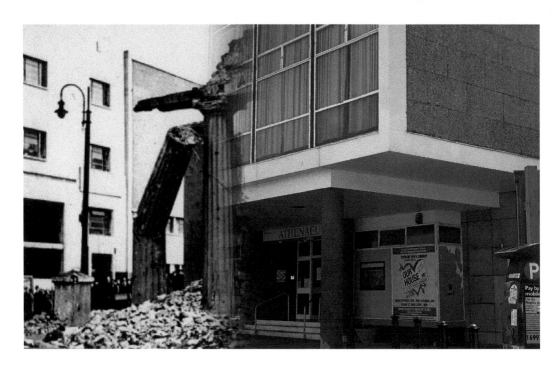

The Athenaeum

The Athenaeum was designed by John Foulston and the foundation stone was laid in 1818. Bombing on 21 April 1941 totally destroyed the building, taking with it some of the oldest prehistoric relics found in the city including remains of prehistoric rhinoceroses, horses, oxen, and deer. The newer Athenaeum was rebuilt in the same location and opened in 1961.

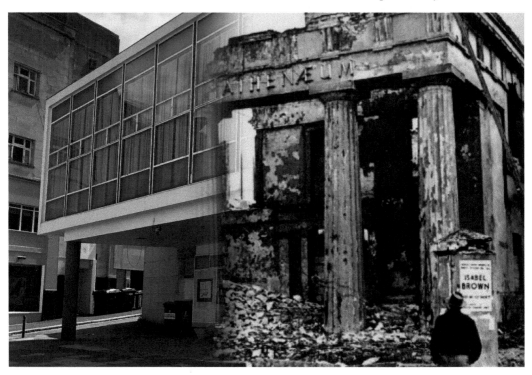

The Royal Hotel, George Street

The lovely older photo shows the Royal Hotel on the left. A boy selling newspapers is standing nearby. Horses and buggies wait on the far side of the road and signs for Western Morning News and Jaeger can be seen. Today, the scene is almost unrecognisable and the beauty that once was has long since disappeared.

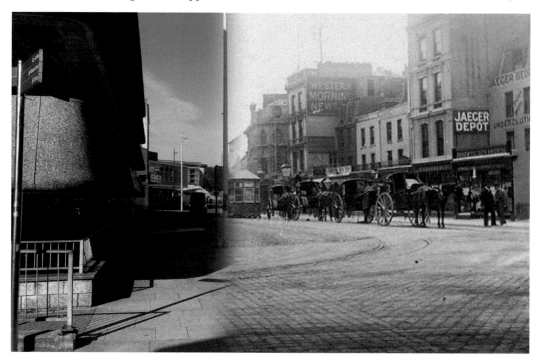

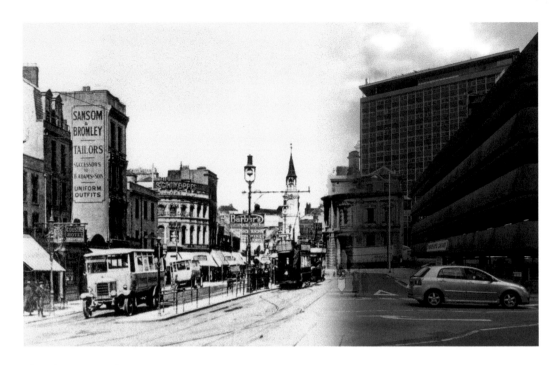

The Theatre Royal, George Street

The lovely older photo shows the Theatre Royal in George Street. Although a magnificent building, it was demolished in 1937 to make way for a purpose-built cinema, The Royal, which later became the ABC in 1958. The only recognisable features today are Derry's Clock and the old bank beside it which is now a public house.

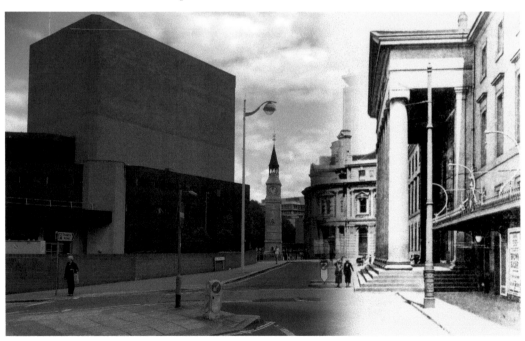

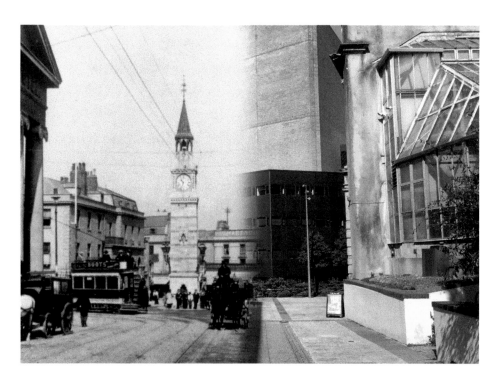

Derry's Clock and the Royal Hotel

The Royal Hotel has long gone together with many of the other buildings in the original photo. Today, Derry's Clock and the Bank public house are overshadowed by a multi-storey car park on the left and the Theatre Royal, built in the late 1970s and early 1980s, in the background.

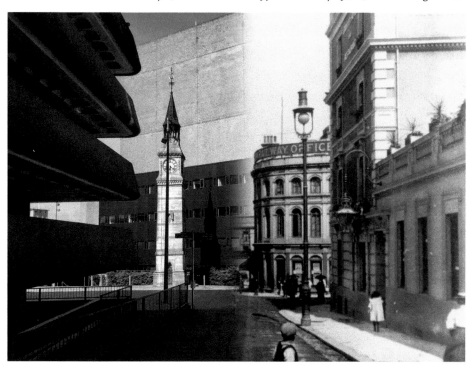

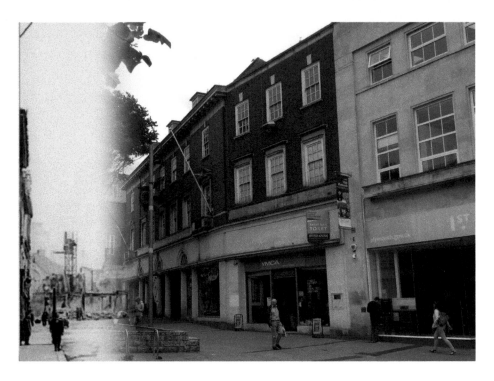

Leicester Harmsworth House

The offices of the Western Morning News (Leicester Harmsworth House) was one of the few buildings to survive the Blitz of 1941. When the city was rebuilt after the war, the building remained in place while the new city was built around it. For many years, it housed Waterstones bookstore, but this closed in 2019.

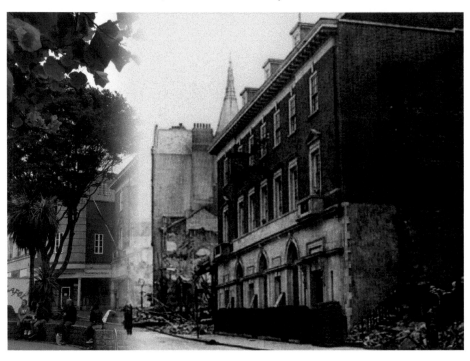

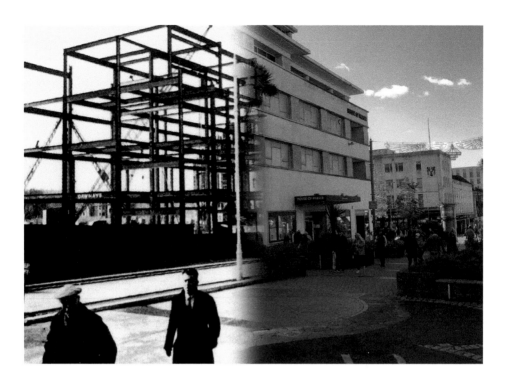

New George Street

The older photo shows the reconstruction of the city and the building of what was to become the city's new departmental stores. In the distance can be seen Leicester Harmsworth House. After the devastation of the Second World War, the new Plymouth was seen as being very modern. Shops have come and gone but many of the buildings of the city centre, although run down, remain much the same as they were when they were built back in the late 1940s and early 1950s.

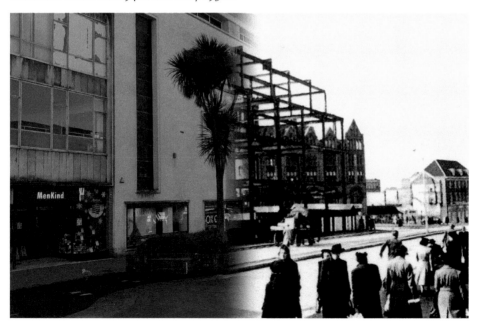

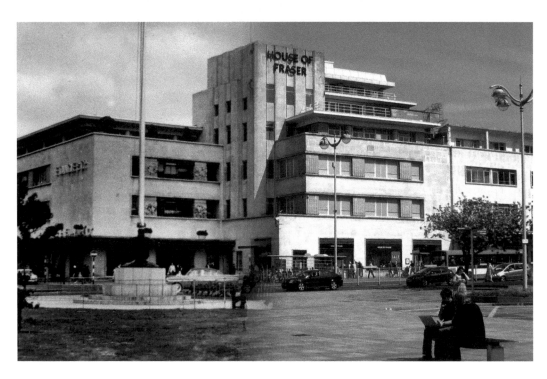

E Dingle's, Royal Parade

The older view shows E Dingle's new premises on Royal Parade in the 1950s. Edward Dingle originally opened a drapery shop at No. 30 Bedford Street, Plymouth, in 1880. In June 1951, Dingle's signed a ninety-nine-year lease and traded on Royal Parade for many years before being bought out by the House of Fraser in 1971.

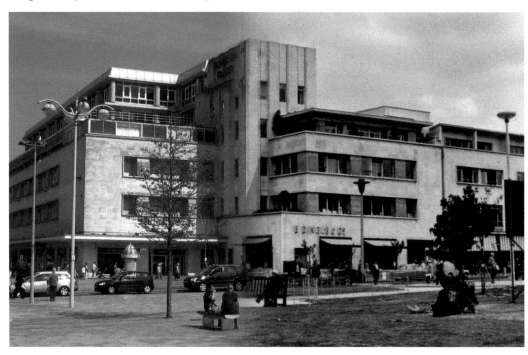

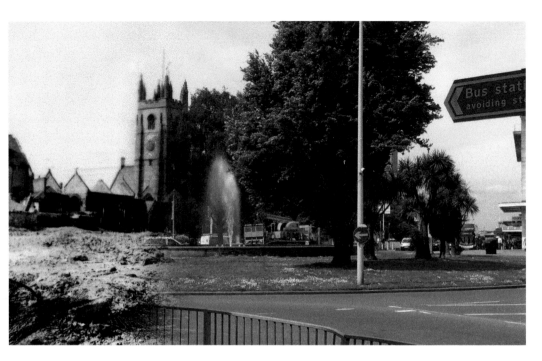

American Soldiers in front of St Andrew's Church and the Municipal Buildings
In the older photo, American soldiers can be seen manning an ack-ack gun amongst the destruction caused by the blitz. In the background, the main part of the church can be seen without its roof, destroyed by the heavy bombing. Today, a fountain stands in much the same position as the troops once stood.

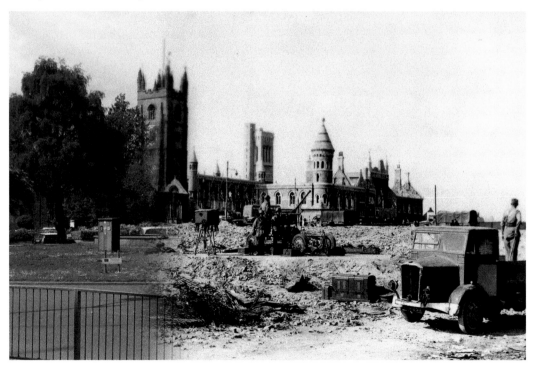

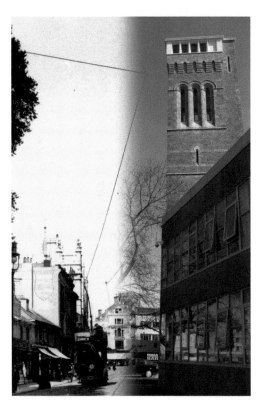

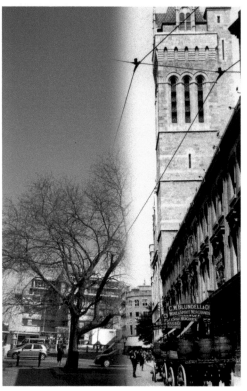

The Guildhall

The older photo shows Plymouth as it once was before the German bombs rained down. This scene would be almost unrecognisable today if it wasn't for the tower of the Guildhall on the right of the photo. It's lovely to see the old streets, trams and horse-drawn carts. The area now forms part of Armada Way which sweeps down from the Hoe towards the city centre.

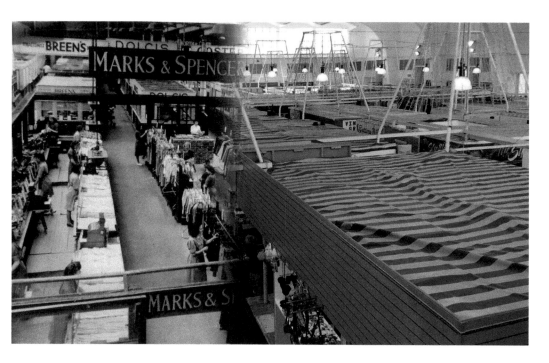

The Market

There has been a market in Plymouth since 1253. When the city was devastated by heavy bombing in 1941, many of the larger businesses moved into the Pannier Market. These included Marks and Spencer's, Costers and Boots. Work started on the present market in 1952 and was completed in 1959. The later colour photo shows the market as it is today.

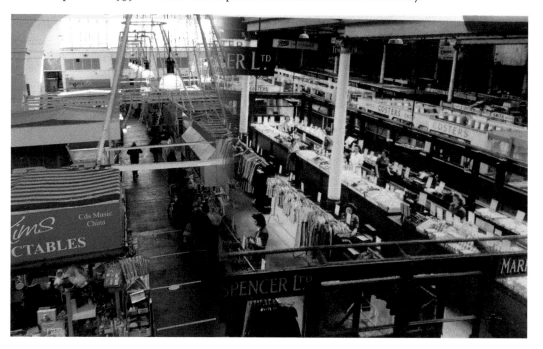

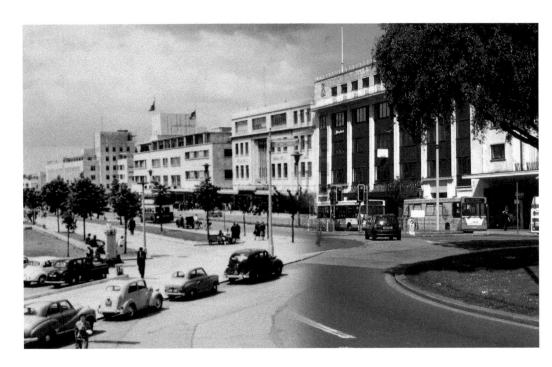

The top of Royal Parade

The first photo shows the newly built shopping centre in the 1950s. There are many cars and buses travelling up and down Royal Parade. Before the war, the streets were narrow and soon became congested. Today's scene appears emptier but the traffic into the city has increased immensely. There is little change apart from the new lamp posts; however, if the tree wasn't so big on the left-hand side of the photo, the Civic Centre, built in the 1960s, would also be able to be seen.

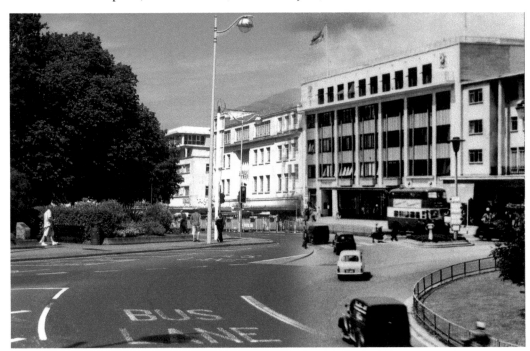

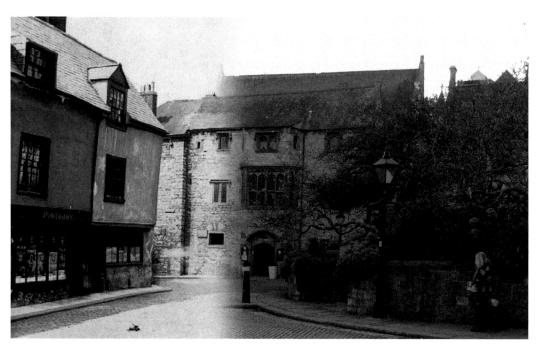

The rear of St Andrew's Church

Beside St Andrew's in the older picture is the Prysten House which dates from the fifteenth century. Today, the buildings on the left, including a shop belonging to Portbury, have now long gone and the Magistrates' Court, built in the late 1970s, now stands in their place.

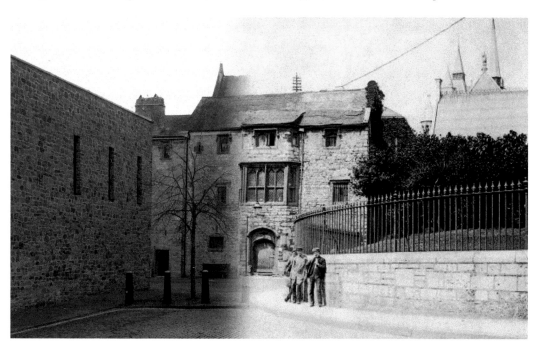

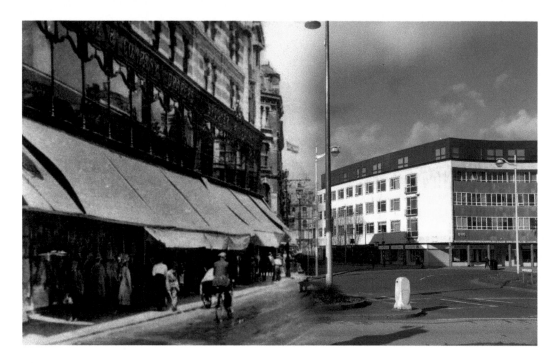

Old Town Street

With the rebuilding of the city centre, little remains today of Old Town Street. In the later photo, the Skipton Building Society and the Royal Bank of Scotland can be seen on the right of the picture and from here to the new Drake Circus Shopping Mall is all that is left of Old Town Street. The original street was once very busy with many shops including photographers, jewellers, drapers and tobacconists.

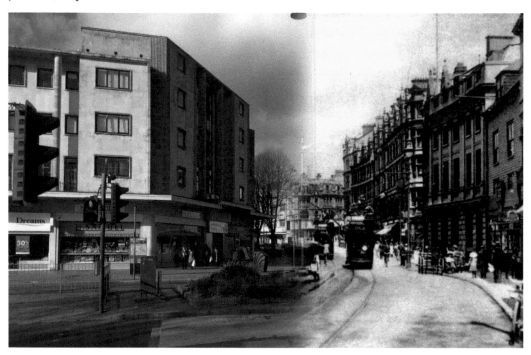

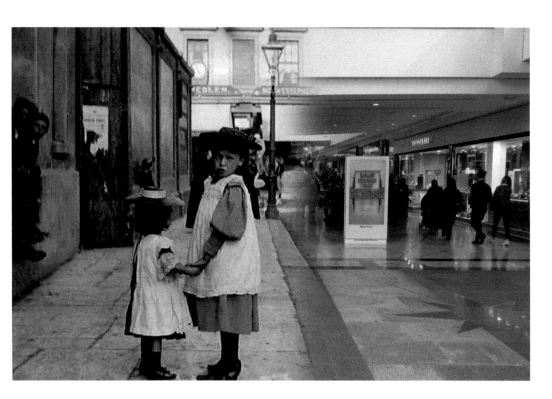

Drake Circus

Drake Circus has seen many changes over the years. It was once famous for its old buildings and the Guinness Clock, which many residents relied on to tell the time. The area was demolished in 1967 to build a new shopping centre which opened in 1971. In 2004, the area was redeveloped again and the new Drake Circus Shopping Mall was built to mixed reactions. It was opened in October 2006.

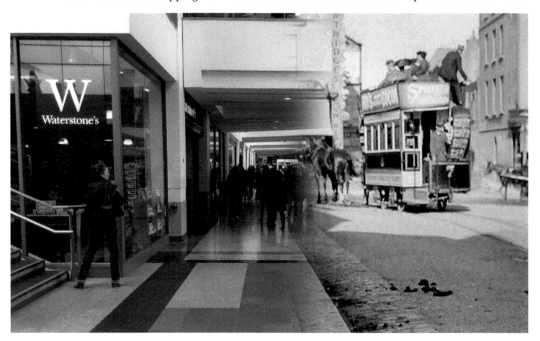

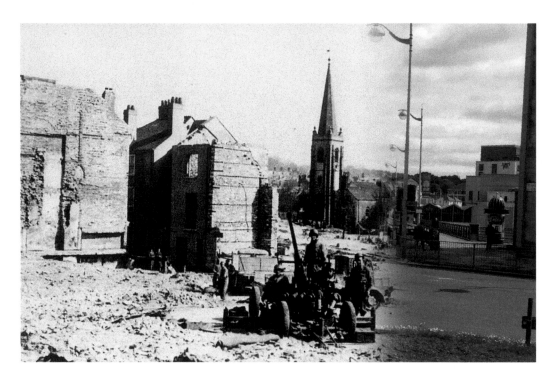

American Soldiers Standing amongst the Ruins with Charles Church in the Background
The bomb-damaged ruins of Charles Church stand on the roundabout at Charles Cross as a monument to the civilians who died in the Second World War. Today, it's dwarfed by the newer, rather odd, Drake Circus Shopping Mall nearby. For many years, a multi-storey car park stood where the mall stands today.

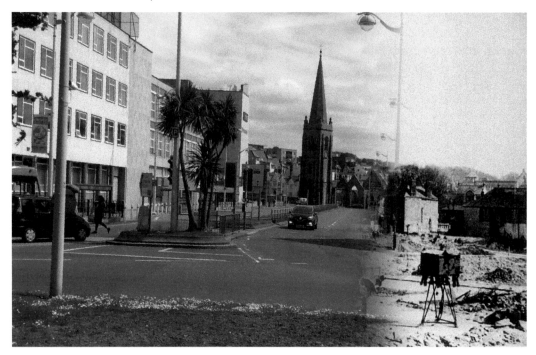

St Andrew's Church, the Post Office and the Municipal Buildings
Much was destroyed in the Blitz of 1941 and only St Andrew's Church remains from the scene in the older photo. In the newer photo, Royal Parade and the House of Fraser building can be seen to the right.

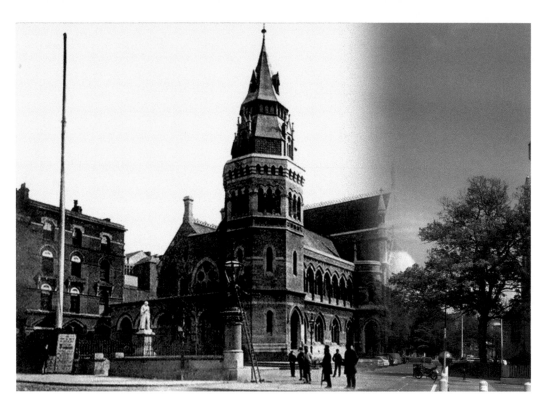

The Municipal Building

The Municipal Building was opened, as part of the Guildhall complex, in 1874 by HRH Prince of Wales, later King Edward VII. It was destroyed by enemy bombing during the first nights of the Blitz in March 1941. Today, the area is taken up by much of Royal Parade and a small car park.

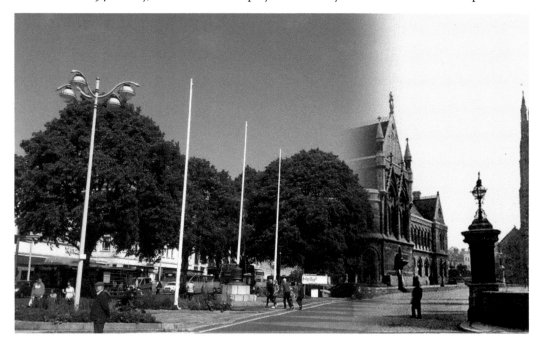

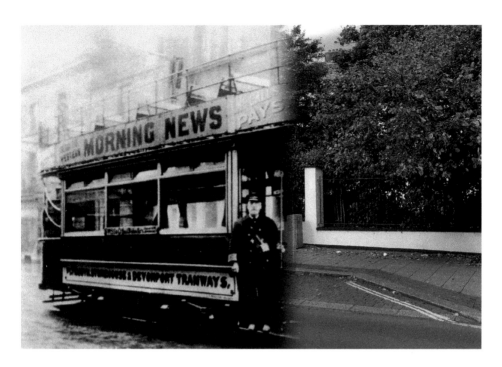

Tram, Union Street

This lovely old tram is outside No. 110 Union Street which, unfortunately, no longer exists. Much of Union Street was bombed during the Second World War but many interesting buildings remained even up until the 1980s. In the 1970s, it was the home to clubs, pubs and interesting second-hand shops. Today, the area where the original photo was taken is far less interesting, housing just a small parking bay.

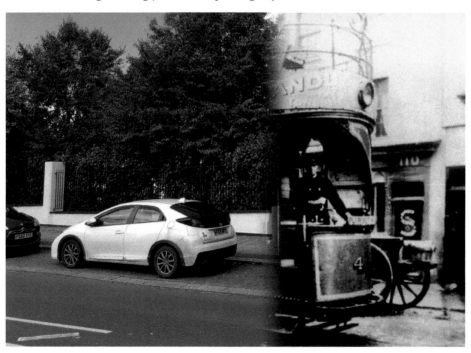

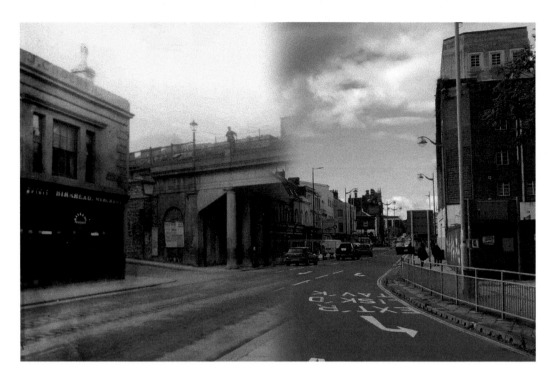

Union Street Arch

The early photo showing Union Street arch was taken at the beginning of the 1900s. The arch carried rail traffic from the nearby Millbay Station and was eventually removed in the 1970s. Until recently, there was a walkway leading from the old Toys R Us building and car park over to the Pavilions entertainments centre, but this too has now gone.

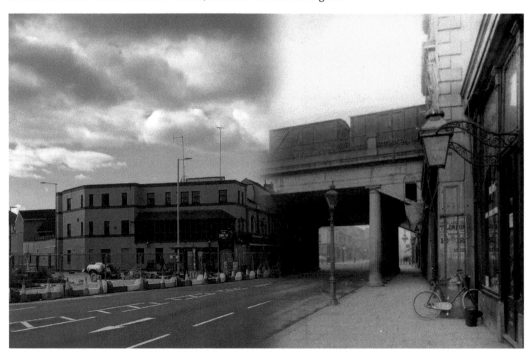

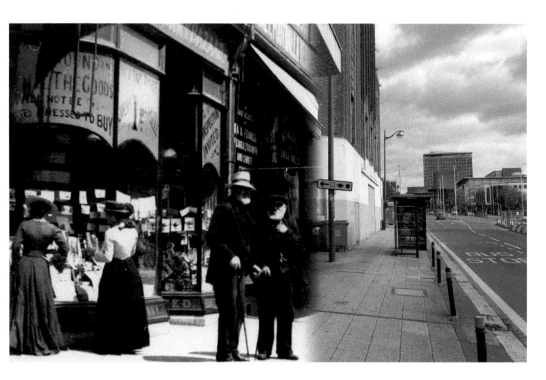

Men Talking, Union Street

The older photo shows the view looking towards the Union Street arch with the town centre in the distance. The area has changed completely nowadays. The shops and buildings are long gone and their replacements have lost much of the charm of the earlier premises.

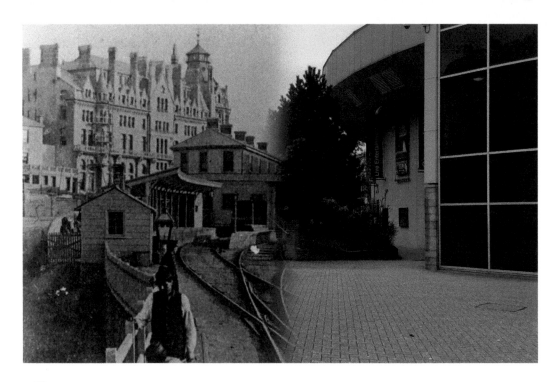

Millbay Station

The tracks ran from Millbay Station straight into the docks. As well as passengers, the trains carried various cargo from ships including gold bars and spices. Built in 1849, it was nicknamed 'The Shabby Shed'. Millbay Station was closed to passengers in 1941 after heavy bombing and the lines were used solely for goods traffic. In 1966, the line was closed to public goods traffic and finally in 1971, the last track into Millbay Docks was closed altogether.

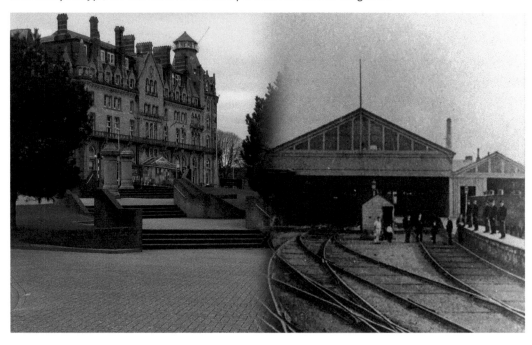

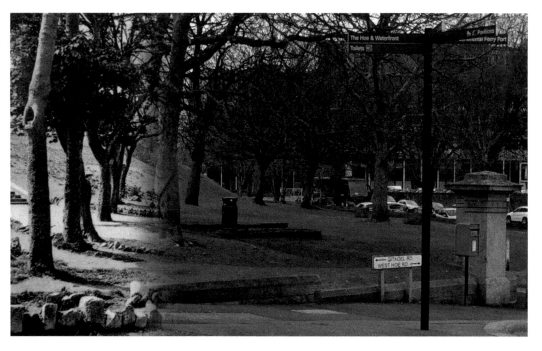

Tank at Millbay Park

The older photo shows the First World War tank which once stood in Millbay Park. It was removed for scrap metal during the Second World War. The buildings in the background have long since disappeared and Ballard House now dominates the area close by.

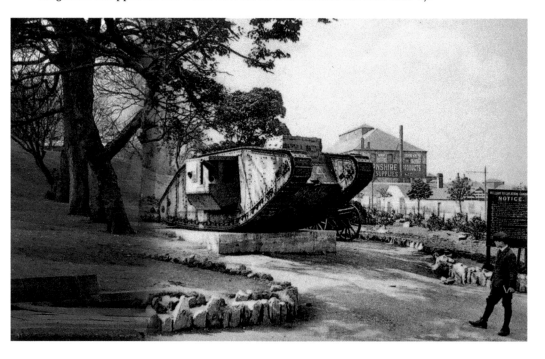

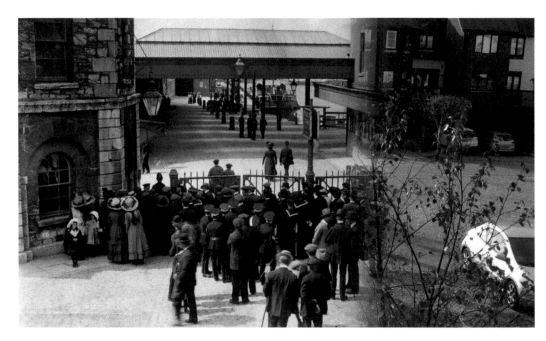

Titanic Survivors at Millbay Docks

On 28 April 1912, survivors from the *Titanic* were brought back to Millbay Docks, fourteen days after the ship had sank. At 8 a.m., the SS *Lapland* moored at Cawsand Bay with the 167 members of the *Titanic* who hadn't been detained in New York for the American inquiry. After midday, the survivors disembarked in an air of secrecy before being put on a special train from Millbay Docks to Southampton.

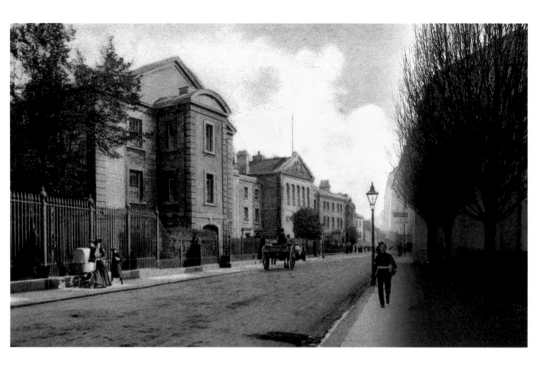

Durnford Street

This street was once the home of doctors, merchants and the well-off. Sir Arthur Conan Doyle assisted at a medical practice at Durnford Street and Sherlock Holmes was said to be based on his colleague Dr Budd. On the left of both photos can be seen the Royal Marines Barracks and, apart from the traffic, much remains the same.

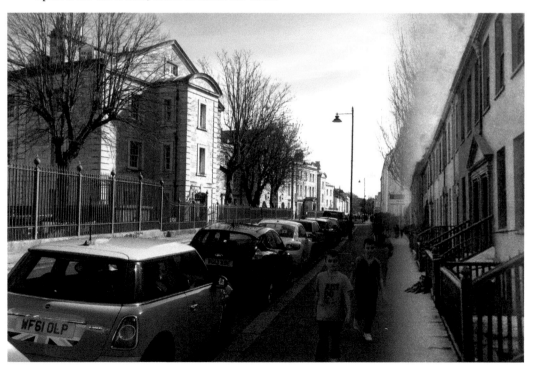

Emma Place, Stonehouse

In the distance, in the older photo, can be seen Stonehouse Town Hall which was erected between 1849 and 1850. It was destroyed in the Second World War. The buildings on the left have now all gone, but many of the buildings on the right of the photo still remain.

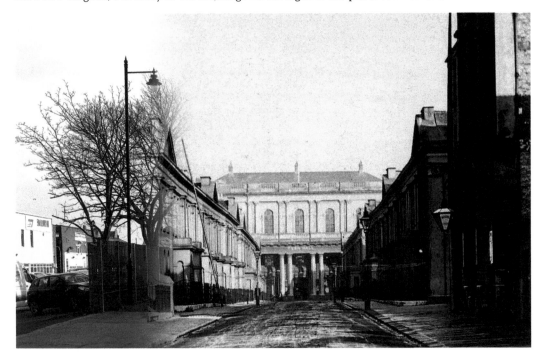

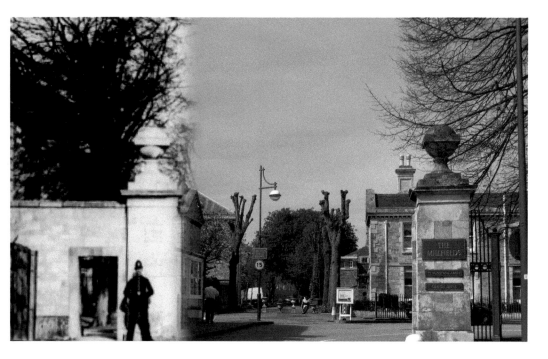

The Royal Naval Hospital, Stonehouse

Today, the Royal Naval Hospital is now Millfields, an upmarket gated community with its own security guards. Work started on the hospital in the late 1700s and it treated patients up until the 1990s. There are some changes to the entrance but much of the outside of the buildings remain the same.

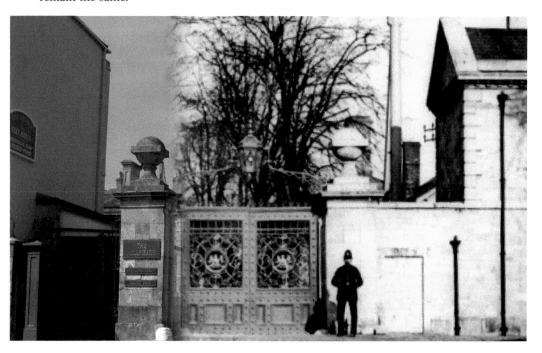

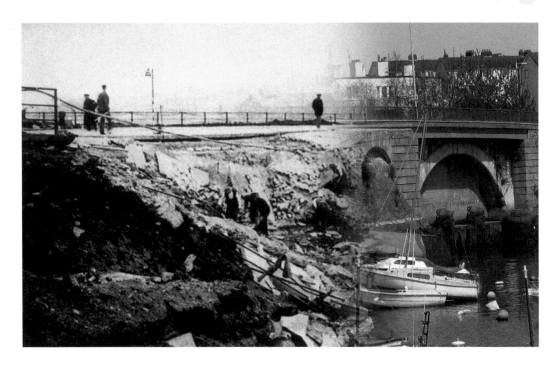

Ha'penny Bridge between Stonehouse and Devonport

The older photo shows Stonehouse Bridge, which was destroyed by bombing in the Second World War. It was once a toll bridge and was known then as Ha'penny Bridge. In 1909, Houdini leapt from the bridge in chains into the waters below and managed to free himself in front of a large crowd who had gathered to watch. Today, the rebuilt Stonehouse Bridge is as busy as it ever was, taking much traffic daily into the city centre.

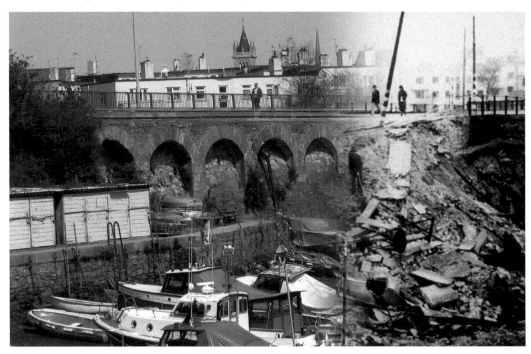

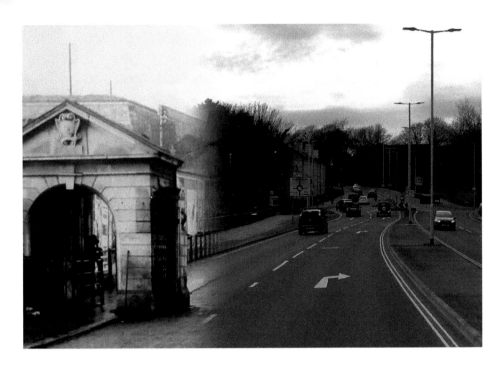

Crossing Stonehouse Bridge

The older photo shows Stonehouse Bridge looking from Stonehouse towards Devonport. A coal cart can be seen crossing in the middle and the once very busy tramlines can be seen embedded in the road. Today, everything is very different and it's hard to imagine the character the bridge once had.

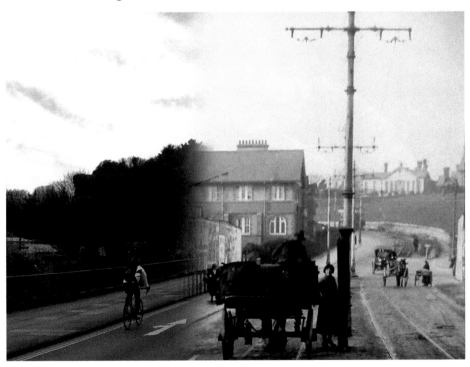

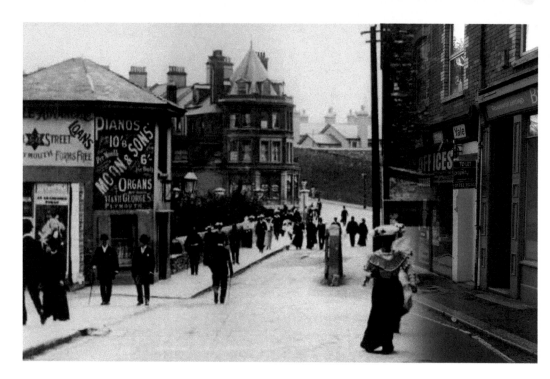

Millbridge

The building on the left of the older photo was once a toll house and tolls were collected up until 1924. Millbridge was originally built in 1525 by Sir Piers Edgcumbe and Stonehouse Creek once flowed past the area in the distance. Then known as the Deadlake, the land was reclaimed in the late 1800s and is now Victoria Park. The building in the distance and the buildings on the right of the photo still remain.

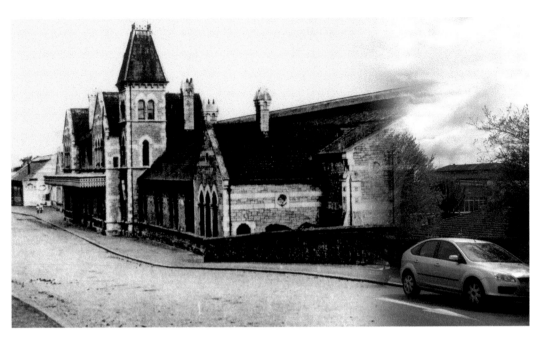

Devonport Railway Station, Kings Road

The station at Kings Road was opened in 1876 and was used extensively. It was damaged by bombing in the Second World War but remained in use after the war until it was closed in 1964. It was eventually demolished and the College of Further Education was built in it's place.

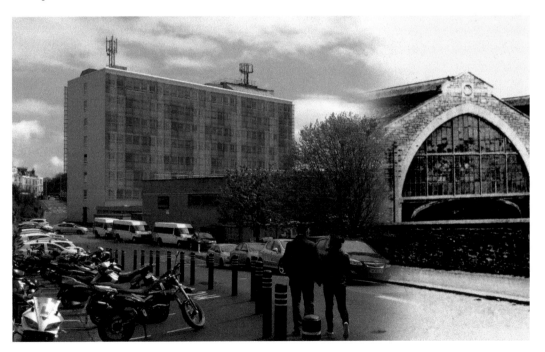

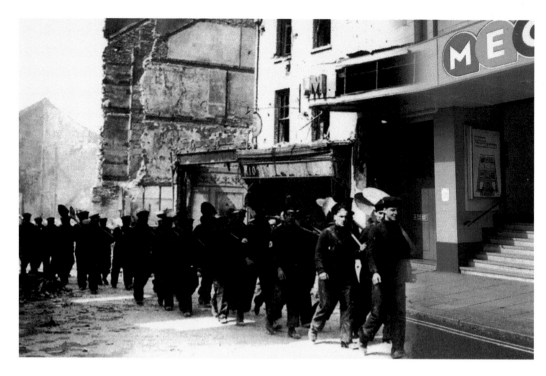

The Forum, Fore Street, Devonport

Once a popular cinema in the middle of Fore Street, the whole area changed dramatically with the bombing of the Second World War. Much of Fore Street was damaged or destroyed and the bottom half of the street was later enclosed within the dockyard. Today, the Forum is a bingo hall with little remaining of the street that once surrounded it.

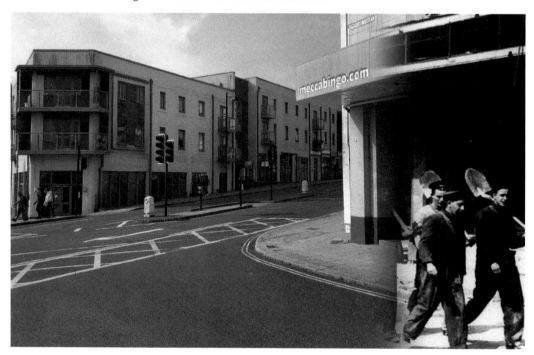

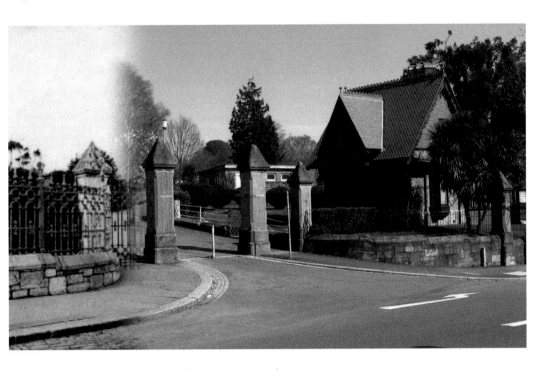

The Swiss Lodge, Stoke Road, Devonport Park

The Swiss Lodge and Devonport Park were renovated several years ago but for many years the lodge lay in a state of disrepair. The lodge was designed by Alfred Norman of Devonport and the park was opened to the public in 1895. Trams regularly passed by this way and the tramlines can be seen in the older photo.

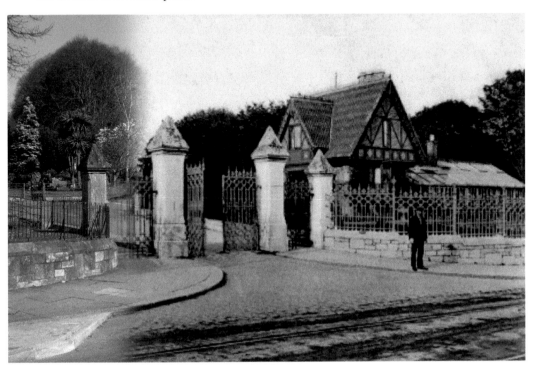

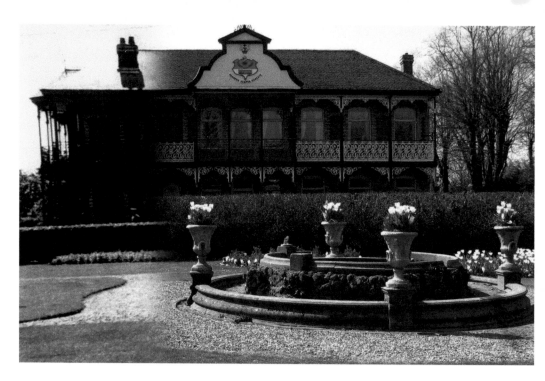

Higher Lodge, Devonport Park

Higher Lodge within Devonport Park can be seen in both of these photos. Today, it's a care home for the elderly but for many years from 1890, the building served refreshments and welcomed visitors to the very popular park. The fountain has altered over the years and much of the more ornate work has disappeared.

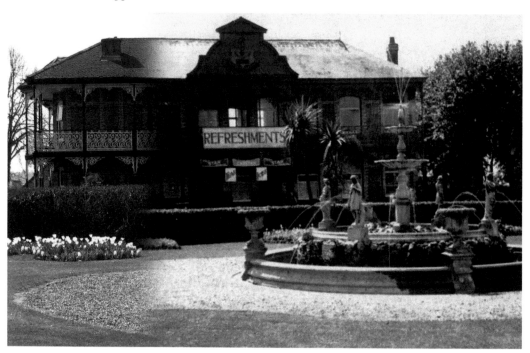

Chapel Street, Devonport

It's hard to imagine nowadays that Chapel Street was once a very busy street with many trams regularly passing by. Chapel Street is still there today but most of the buildings have now disappeared, as have the trams. The last tram ran in Plymouth in 1945. The Forum building in the background is the only thing recognisable from the past.

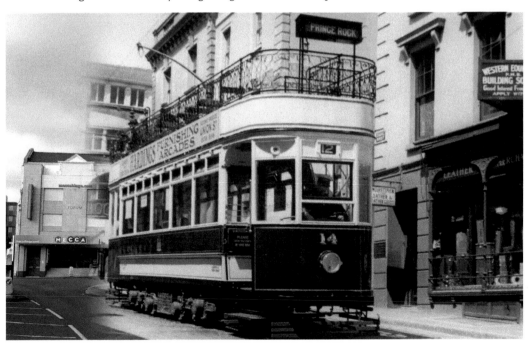

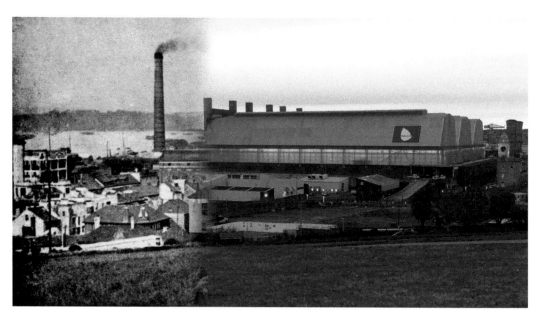

Children Sitting in the Grass with the Dockyard in the Background

Much has changed between the two photos. Many of the buildings, including the smoking chimney, in the older picture have long since disappeared, swallowed up by the dockyard. The three covered dry docks, which were built in the 1970s, dominate the scene in the later photo.

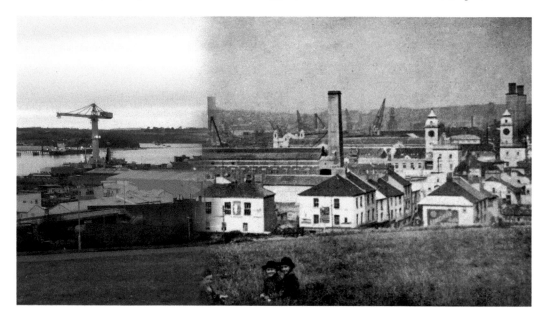

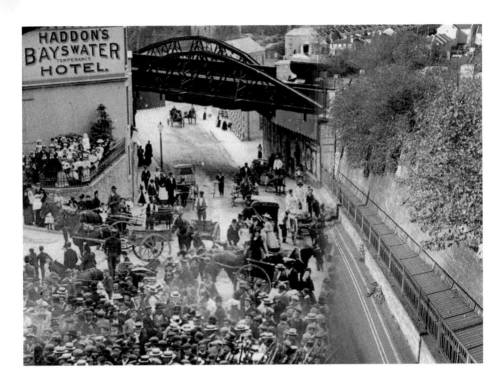

Saltash Road towards Pennycomequick

The first photo shows a large gathering near the train station at North Hill in the early 1900s. A steam train can be seen crossing the bridge near to Haddon's Bayswater Temperance Hotel. There are many horses and carts on what is now a very busy road full of cars and buses.

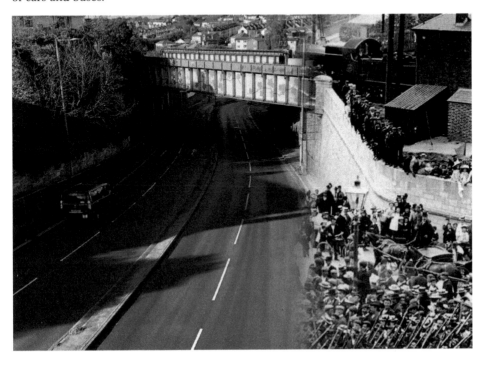

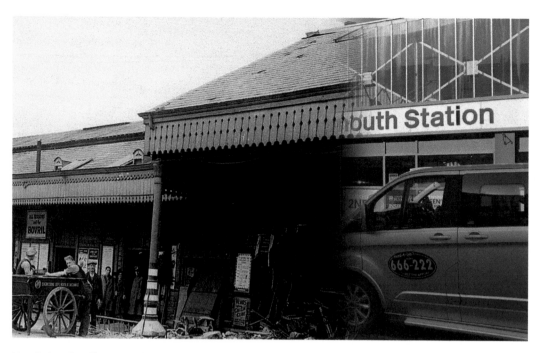

North Road Railway Station

Much has changed over the years since North Road Station was first built in 1877. Rebuilding work to enlarge the station started in 1935 but this was interrupted by the war. The older photo shows the station after bomb damage and the newer photo shows the station as it appears today.

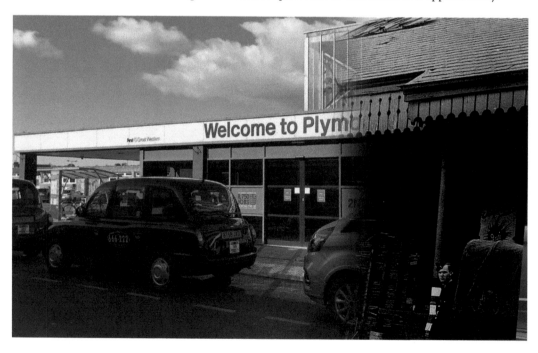

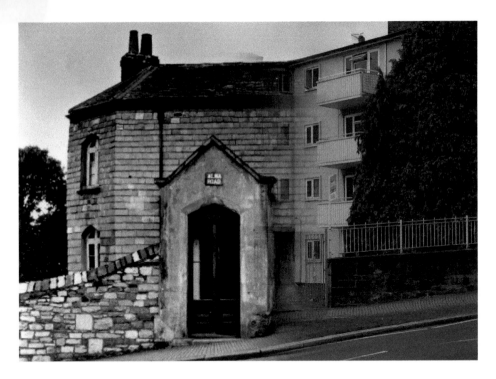

The Toll House, Alma Road, Pennycomequick

The tidal water from Stonehouse Creek once flowed all the way back to Pennycomequick. There was a bridge at this spot and a toll had to be paid to cross it. The older photo shows the long-since disappeared Toll House. When the creek was dammed off in 1890, the area around Pennycomequick soon dried up and there was no need for either the bridge or the Toll House.

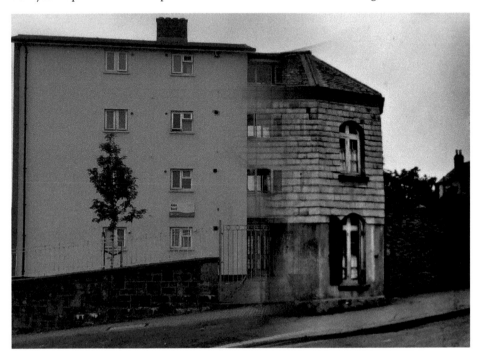

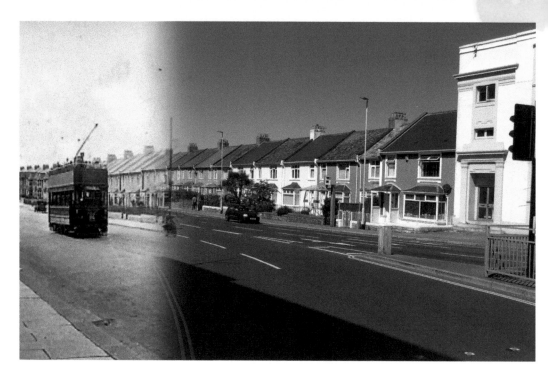

Milehouse Road

The lovely older photo shows trams travelling along Milehouse Road in the general direction of Central Park. There is only one car and one motorcycle travelling along the road which today is far more busy with traffic of all kinds. The building on the right still remains and today houses the Embassy Snooker Club.

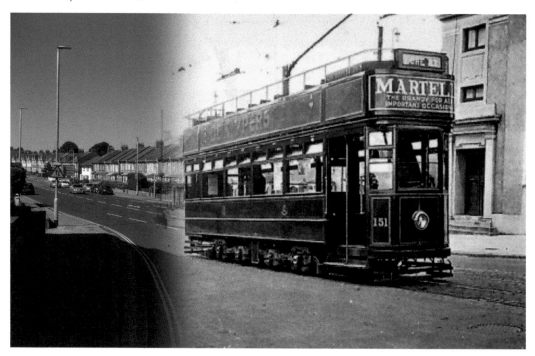

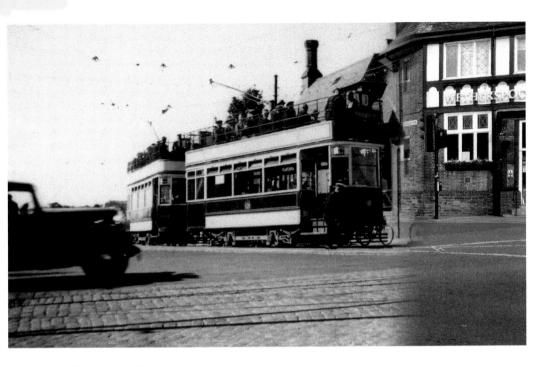

The Britannia, Milehouse

Heavily laden trams pass by the Britannia Inn possibly dropping passengers off at the nearby Plymouth Argyle ground in the older photo. There are also many cyclists and a car in the picture. Today, the trams have long gone but much of the layout of the road and the Britannia Inn remain much the same.

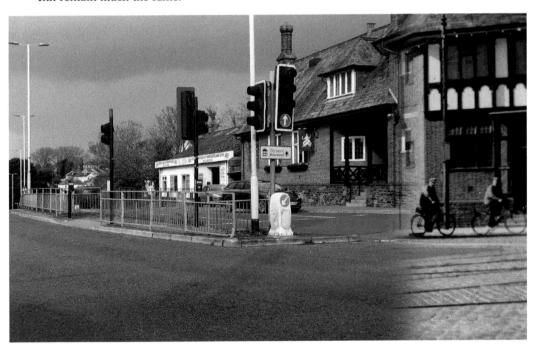

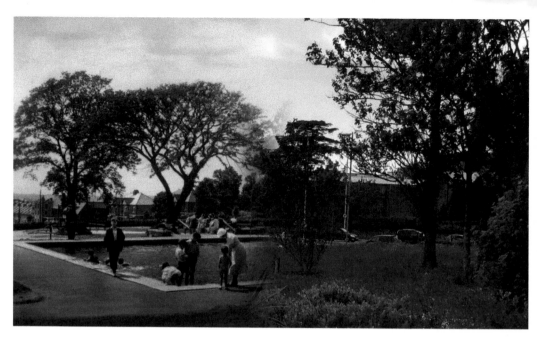

The Paddling Pool at Central Park

The paddling pools at Central Park were popular with children for many decades. Central Park and the paddling pools (which formed part of the 'Children's Corner') were opened by Mayor Mr J. Clifford Tozer in July 1931. Today, there's no sign that they ever existed and much of the area is now parking space.

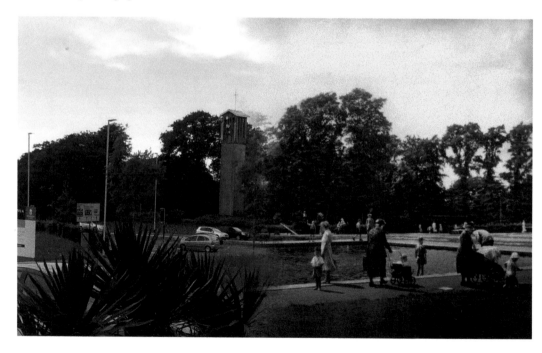

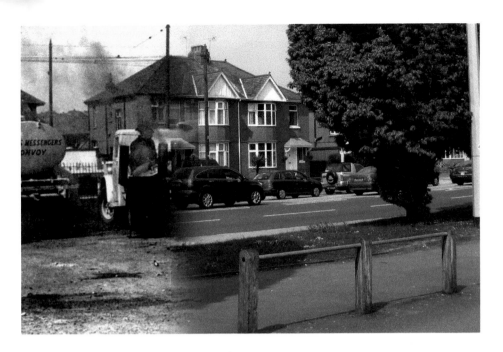

The Queen's Messengers at Central Park

The Queen's Messengers Convoy were a familiar sight during the Second World War and were set up to feed the homeless and supply warm food and drink to people without electric and water supplies. The Queen's Messenger Food Convoys were named after Queen Elizabeth (the mother of today's Queen Elizabeth) who donated money for the first eighteen convoys.

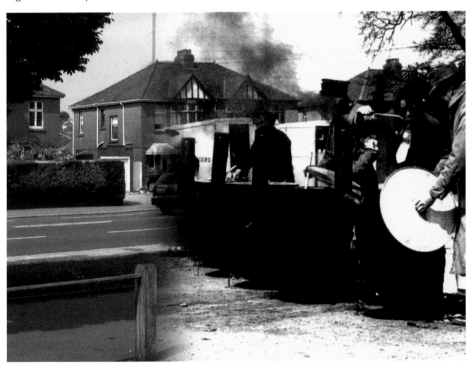

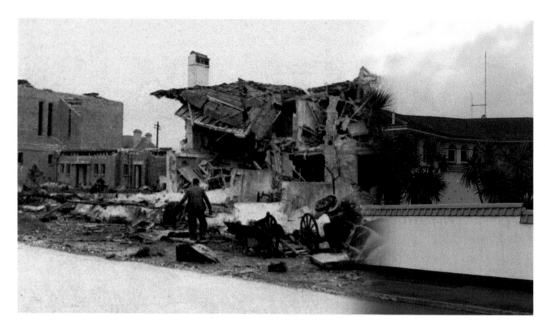

Sungates, Torr Lane, Hartley

Sungates was built in 1927 and suffered severe damage during the bombing of the Second World War. It was largely rebuilt in 1952. Set into the wall is a medieval cross in between two boundary stones. The cross marks the point where an ancient road from Sutton Pool to Roborough Down crossed a track which ran from Plymouth to Saltash. The boundary stones are for the tythings of Weston Peverell and Compton Giffard.

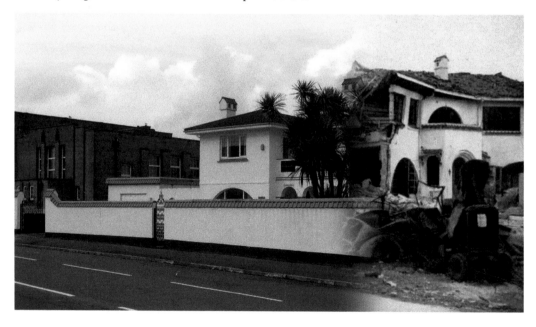

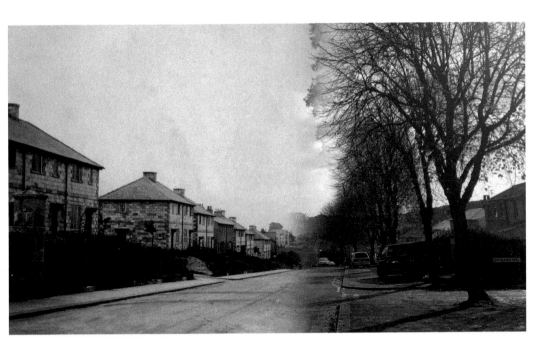

Swilly Road

The houses and layout shown in the older photo make Swilly Road, now renamed North Prospect Road, easy to recognise. The picture shows a street empty of both people and traffic. Following the road downwards eventually leads to Milehouse. In the 1920s, Swilly was the first council housing estate built in Plymouth. It was used to accommodate officers returning from the First World War. Bombed in the Second World War, the area was later renamed North Prospect in the 1970s.

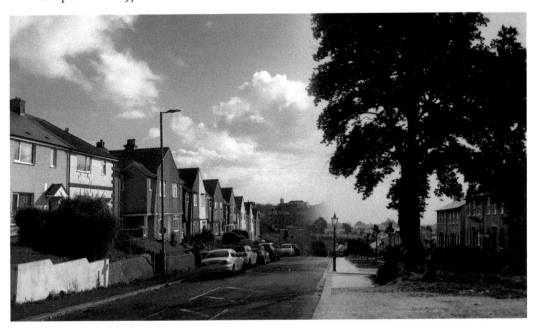

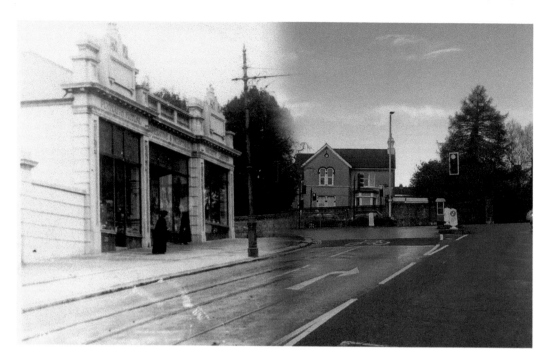

The Co-op, Peverell

The Co-op at Peverell was opened in the early 1900s. The tram in the older photo has its destination as 'Royal Theatre' which was the termination point by Derry's Clock. The Co-op has greatly expanded over the years but still remains in the same place. The wall at the top of the road is still there and runs along Outland Road.

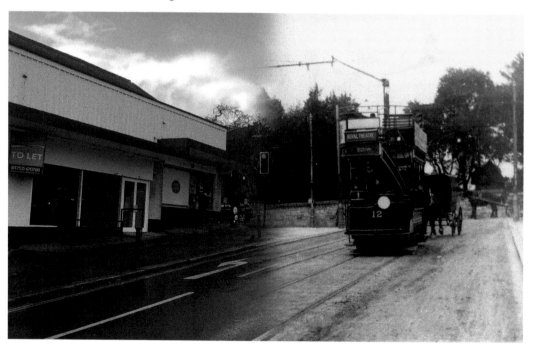

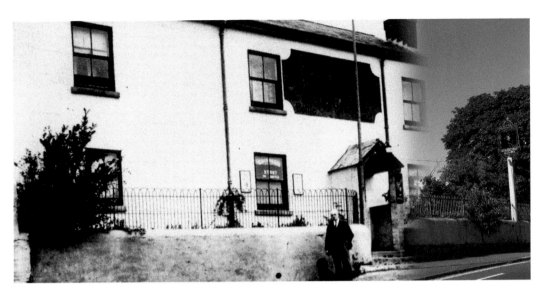

The Blue Monkey Inn, Higher St Budeaux

Although the public house has now been knocked down, the area near to the Higher St Budeaux Church will probably always be known as the Blue Monkey. The inn had previously been called Church Inn, St Bude Inn, St Budeaux Inn and Ye Old St Budeaux Inn before becoming the more well-known Blue Monkey.

 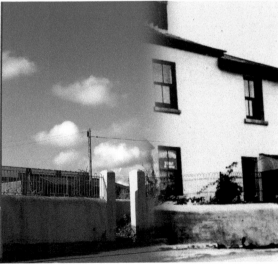

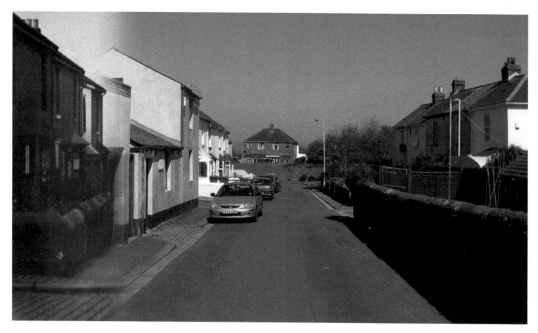

Ernesettle Road

The earlier photo shows Ernesettle Road in around 1910. These houses still stand today although traffic has increased drastically in the last 100 years and, in the distance, where you can see just open countryside and the River Tamar, the Parkway now cuts through the land taking travellers to Cornwall over the Tamar Bridge.

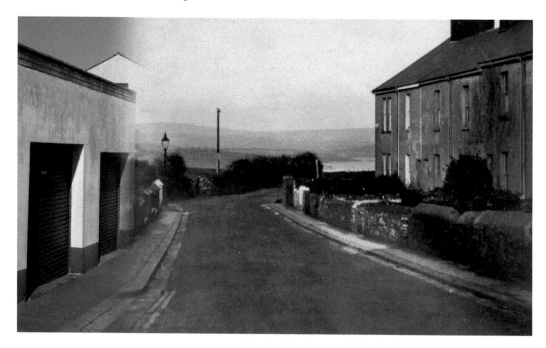

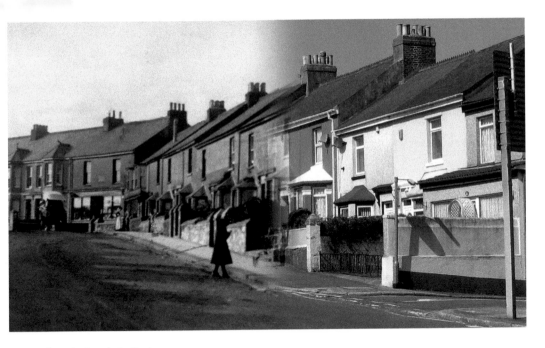

Victoria Road, St Budeaux

This was once Higher Lea Terrace which was located at the top of Higher St Budeaux. The road and the houses have changed little in the last 100 years. The shop seen on the right was once owned by W. Tozer and was Higher St Budeaux's post office.

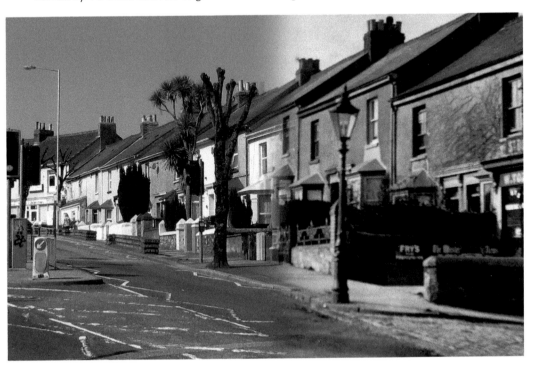

Normandy Way, St Budeaux

Before the Americans passed this way in the Second World War, this street was better known as Tamar Terrace. The houses on the right still remain and the church has been joined to an adjacent house and is now the home to the Bridge-End Club.

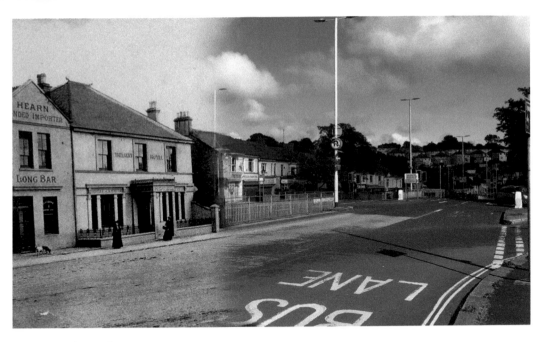

St Budeaux Square

The buildings are all still there, only the road layout and the very busy flow of traffic are different. The once very popular Trelawny Inn has now gone forever and today the building houses a tanning salon and Pizza Hut.

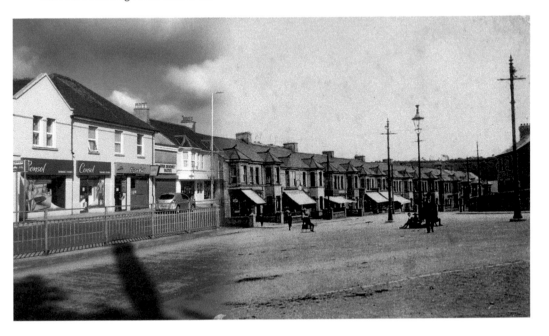

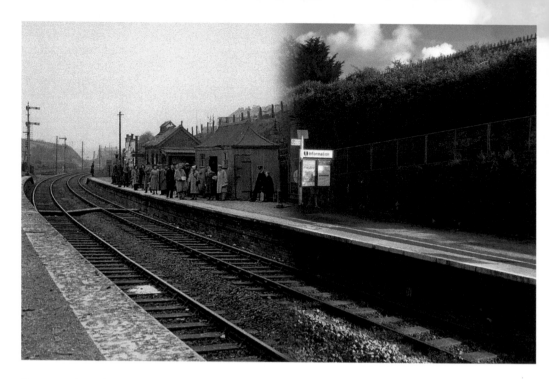

Ferry Road Station, St Budeaux

St Budeaux Station was once very busy taking passengers into Plymouth for work and for shopping. Today, the station is still there but isn't as popular as it once was, with many people having their own cars or catching the bus. The first photo shows the station after bombing during the Second World war.

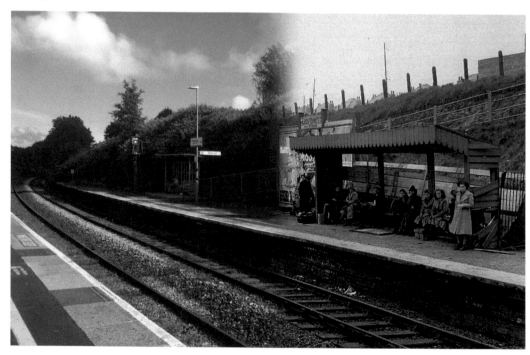

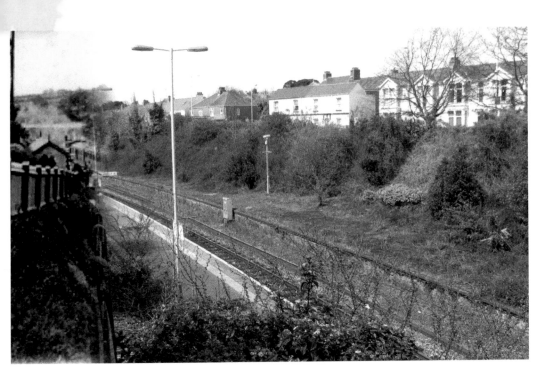

Victoria Road Station, St Budeaux
The covered area on the right of the picture was used to keep dockyard workers dry on rainy days as they waited for their trains into work. It was once a very busy station but today it's eerily quiet and isn't a place that you would want to hang around especially once it starts to get dark.

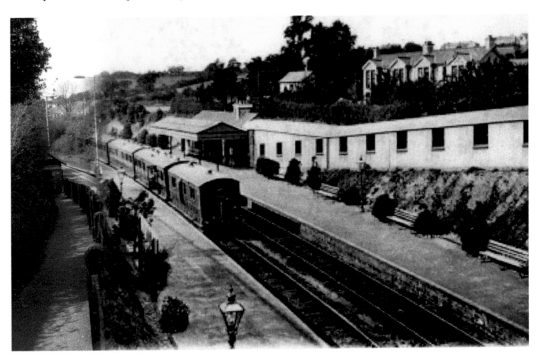

The US Army Base, Vicarage Road, St Budeaux

In January 1944, the US Army set up camp at Vicarage Road in preparation for the D-Day landings. Altogether it housed 60,000 troops on their way to Normandy. It was also a reception centre for returning troops from July 1944. Vicarage Road was later renamed Normandy Hill and today, much of the area where the camp once was is grassed over.

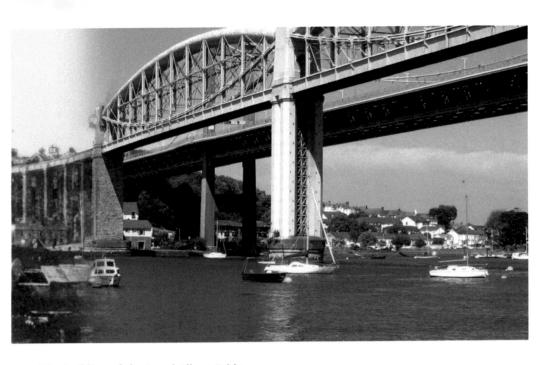

The Building of the Royal Albert Bridge

The Royal Albert Bridge was built in 1859 by Isambard Kingdom Brunel and the original photo shows its construction. Today, the Royal Albert Bridge stands beside the Tamar road bridge which was opened in 1961. Both bridges are very busy and travelling across the Royal Albert Bridge by train gives a magnificent view of the River Tamar.

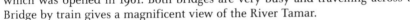
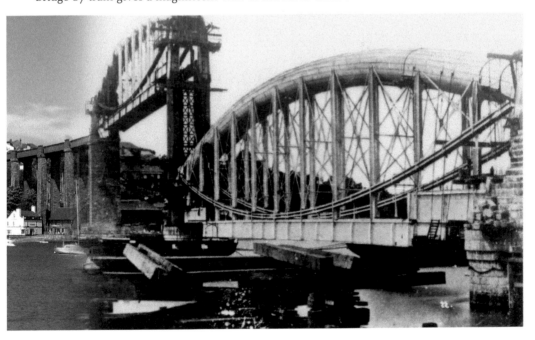

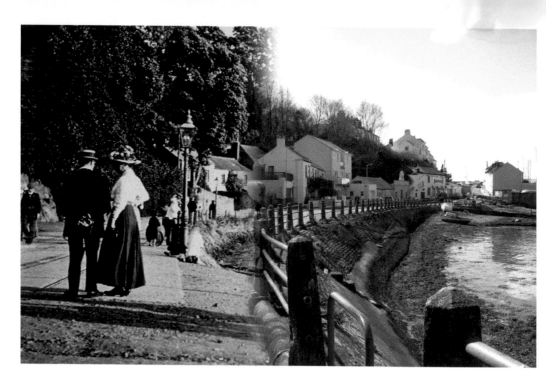

Regatta Day, Saltash Passage

The first photo shows the day before the annual regatta in 1908 featuring many women with fancy hats and parasols. The scene today hasn't really changed that much, although a park was built near the waterfront in the 1950s. All of the original houses in the first photo remain but some have been added to in the last few years.

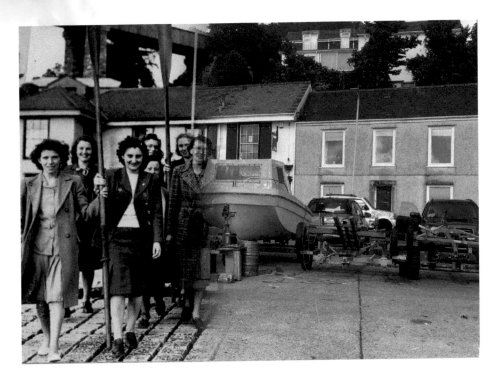

The Baptists Ladies Boating Club, Saltash Passage

The first photo shows the Baptists Ladies Boating Club holding a board with the name of their boat, *Rowena*. This board was fixed to the transom and used as a backrest in the rear seat. The Royal Albert Bridge Inn is in the background. Some older members of the community might recognise some of the faces in this picture. A solitary house stands on Vicarage Road (later Normandy Hill). This section of the road has long since changed with the inclusion of several newer houses.

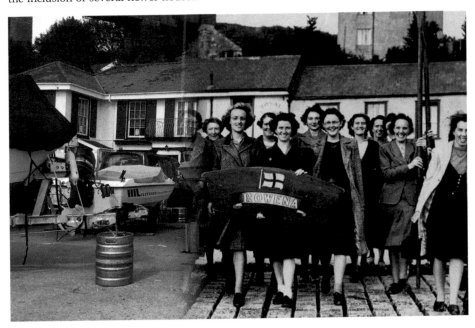

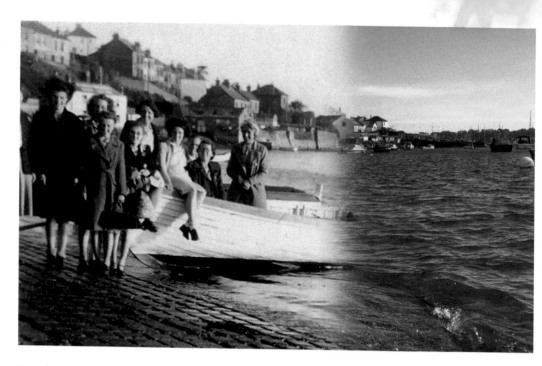

Members of the Boating Club, Saltash Passage

The top photo shows members of the local Boating Club with their boat at Saltash Passage on 30 June 1947. The 'hards' laid down by the American servicemen in 1944 can be seen in the foreground. The front has now changed a bit and the building on the right of the picture has now gone and has been replaced by the yacht club. The area will be instantly recognisable to most residents of St Budeaux and the houses in the background have changed little over the years.

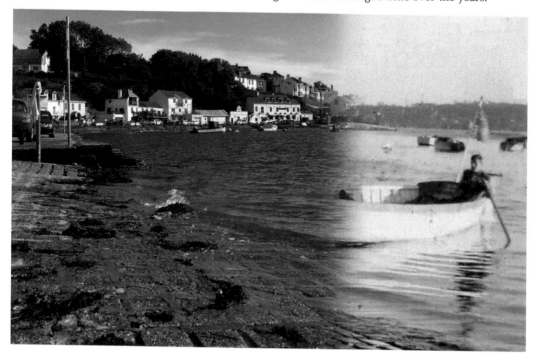

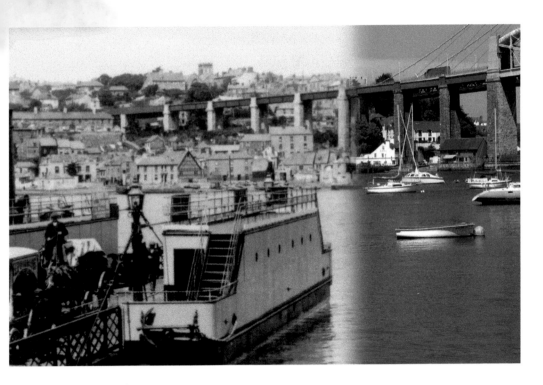

The Ferry, Saltash Passage

The ferry ran for hundreds of years before being discontinued in 1961 when the Tamar Bridge was opened to road traffic. The view hasn't changed too much and the slipway can still be seen, as can the slipway on the Saltash side. Many of the older buildings on the Saltash side have long since been demolished.

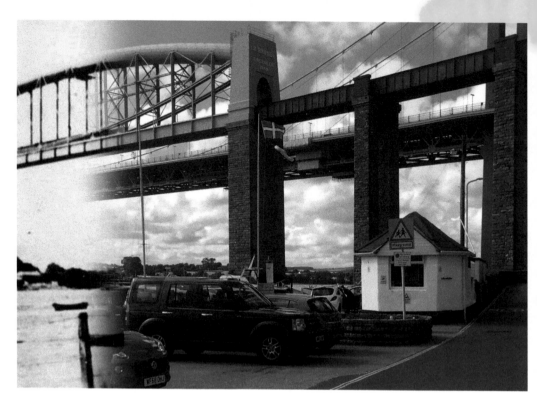

A Tram, Saltash Passage

It's been a long time since trams ran to Saltash Passage. The journey from the centre of Plymouth to Saltash Passage was the longest tram journey you could take back then, covering around 9 miles. Although, the trams are long gone, the tramlines still lie beneath the modern tarmac road and occasionally appear whenever there's a pothole or other roadworks.

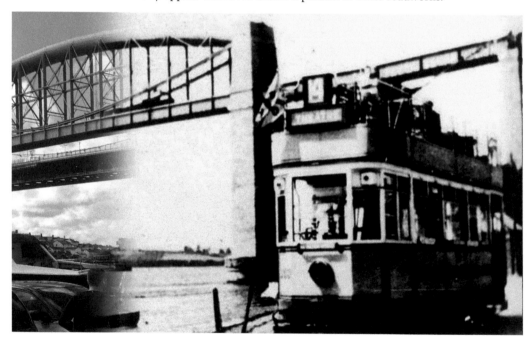

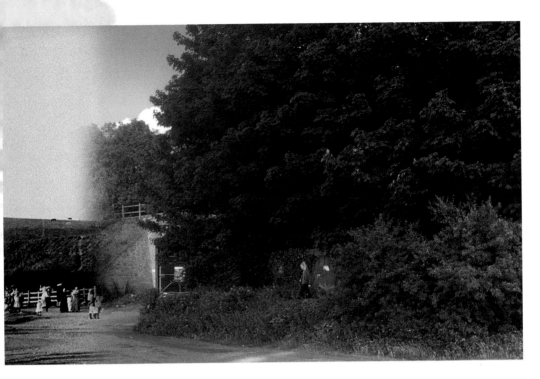

Travellers, Saltash Passage

In the early 1900s, travellers lived beside the Royal Albert Bridge and made and sold pegs. Today, the area seen in the older photo, falls within MOD property and leads to the nearby armaments depot on the River Tamar.

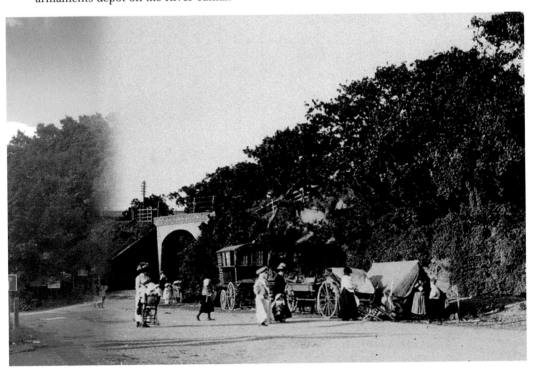

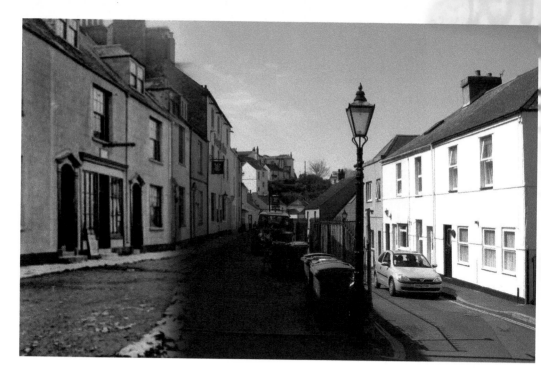

Turnchapel

Parts of Turnchapel have changed little over the years, as can be seen in these two photos. Funnily enough, a 'Victorian' lamp post appears in the later photo but was never there in the original. Modern wheelie bins can be seen chained to the nearby fence but overall, the scene remains much the same.

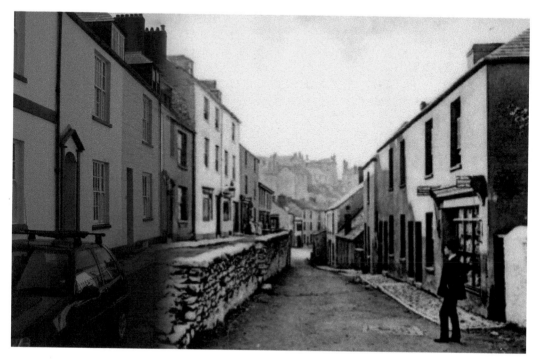